The Sepik River Region

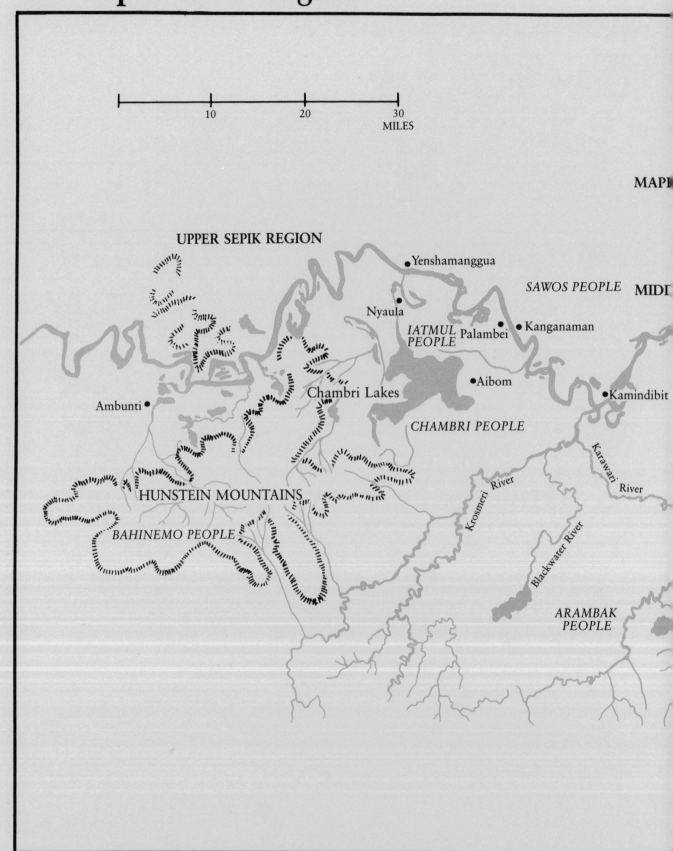

UPPER SEPIK REGION

MAPI

Yenshamanggua

SAWOS PEOPLE MIDD

Nyaula

IATMUL Palambei Kanganaman
PEOPLE

Chambri Lakes

Aibom

Kamindibit

CHAMBRI PEOPLE

Ambunti

HUNSTEIN MOUNTAINS

Karawari
River

Krosmeri River

BAHINEMO PEOPLE

Blackwater River

ARAMBAK
PEOPLE

10 20 30
MILES

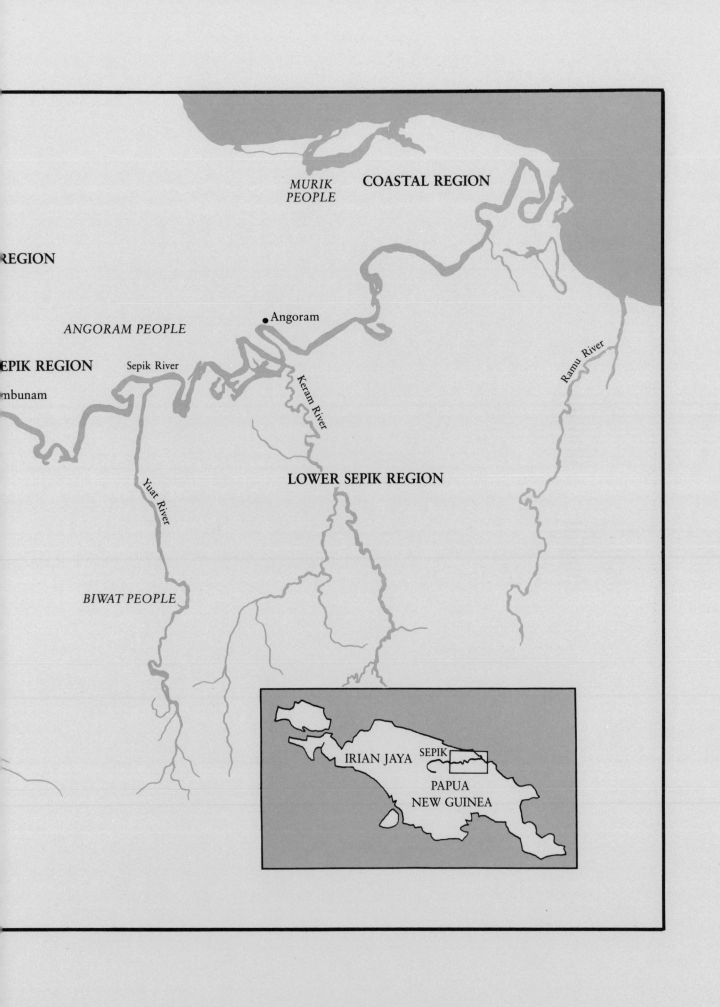

MURIK
PEOPLE

COASTAL REGION

REGION

ANGORAM PEOPLE

•Angoram

EPIK REGION

Sepik River

Keram River

mbunam

LOWER SEPIK REGION

Ramu River

Yuat River

BIWAT PEOPLE

IRIAN JAYA SEPIK

PAPUA
NEW GUINEA

PEOPLE OF THE RIVER

PEOPLE OF THE TREE

Change and Continuity in Sepik and Asmat Art

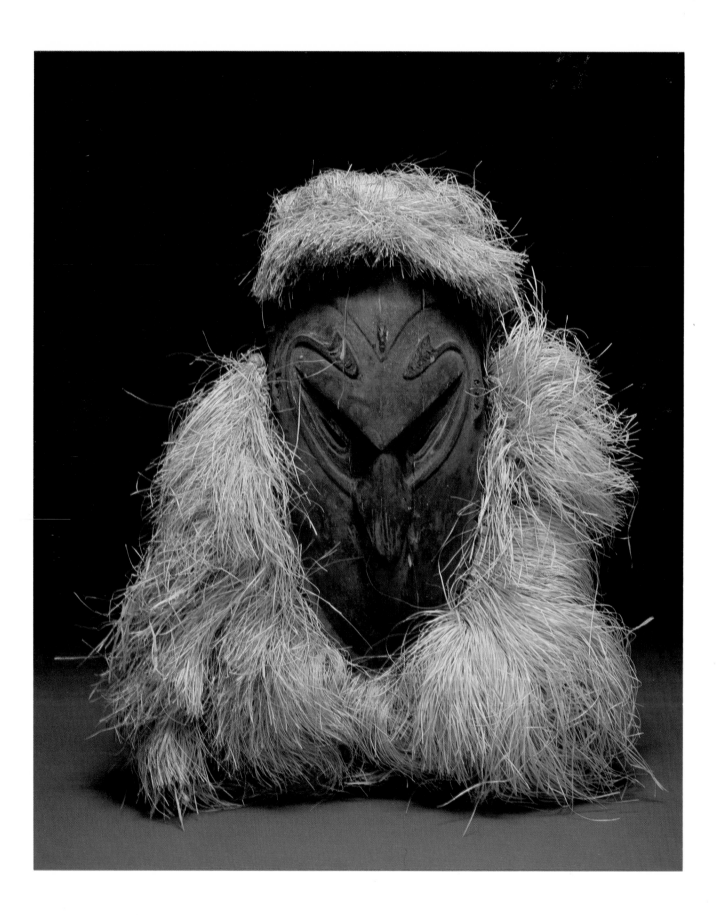

PEOPLE OF THE RIVER

PEOPLE OF THE TREE

Change and Continuity in Sepik and Asmat Art

Organized by Minnesota Museum of Art
in cooperation with the
Crosier Asmat Museum, Hastings, Nebraska

15 January - 26 March 1989
Landmark Center Galleries
Saint Paul, Minnesota

PEOPLE OF THE RIVER, PEOPLE OF THE
TREE: Change and Continuity in Sepik and Asmat
Art was organized by Minnesota Museum of Art, in
cooperation with the Crosier Asmat Museum,
Hastings, Nebraska. The project is made possible, in
part, by grants from the National Endowment for
the Arts, the Minnesota Humanities Commission in
cooperation with the National Endowment for the
Humanities, the Nebraska Committee for the
Humanities, an affiliate of the National Endowment
for the Humanities, the Crosier Fathers and Brothers
Province, Inc, and a contribution from Opperman
& Paquin Law Firm.

Major operating support for Museum programs for
the current fiscal year is provided in part by the
Dayton Hudson Foundation through the
contributions of Dayton's and Target Stores; First
Bank System Foundation; Northwest Area
Foundation; the Ramsey County Commissioners;
and United Arts. This activity is made possible in
part by a grant provided by the Minnesota State
Arts Board through an appropriation by the
Minnesota Legislature, and in part by a grant from
the National Endowment for the Arts. Minnesota
Museum of Art is the recipient of a McKnight
Foundation Award administered by the Minnesota
State Arts Board.

Notes to the Catalog

Unless otherwise indicated, all works are in the
collection of Minnesota Museum of Art. Unless
otherwise noted, all dimensions are given in inches,
height precedes width precedes depth. Catalog
entries were prepared by Leanne A. Klein (L.A.K.)
and Eliza W. Miller (E.W.M.).

(cover)
Artist Unknown, Upper Sepik region
May River - Tauri village
Canoe Prow
wood, paint
29 x 11 ½ x 3 ½
Gift of Howard and Eunice Gelb
79.15.139

AMANDOS AMONOS, New Guinea, Irian Jaya
Asmat people - Jamasj village
Canoe Prow of Soul Ship *(wuramon)*
painted wood
30 x 6 x 6
Collection Crosier Asmat Museum
0697

(frontispiece)
Artist Unknown, Sepik River Coastal region, Ramu
River
Mask
wood, paint, fiber
25 x 26 x 6 ¾
Acquisition Fund Purchase
73.56.02

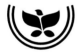
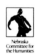
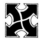

Nebraska
Committee for
the Humanities

·U N I T E D A R T S·
416 Landmark Center, 75 West 5th Street, St. Paul, Minnesota 55102 (612) 292-3222
Minnesota Museum of Art receives major funding from United Arts.

Accredited by the
American Association
of Museums

Contents

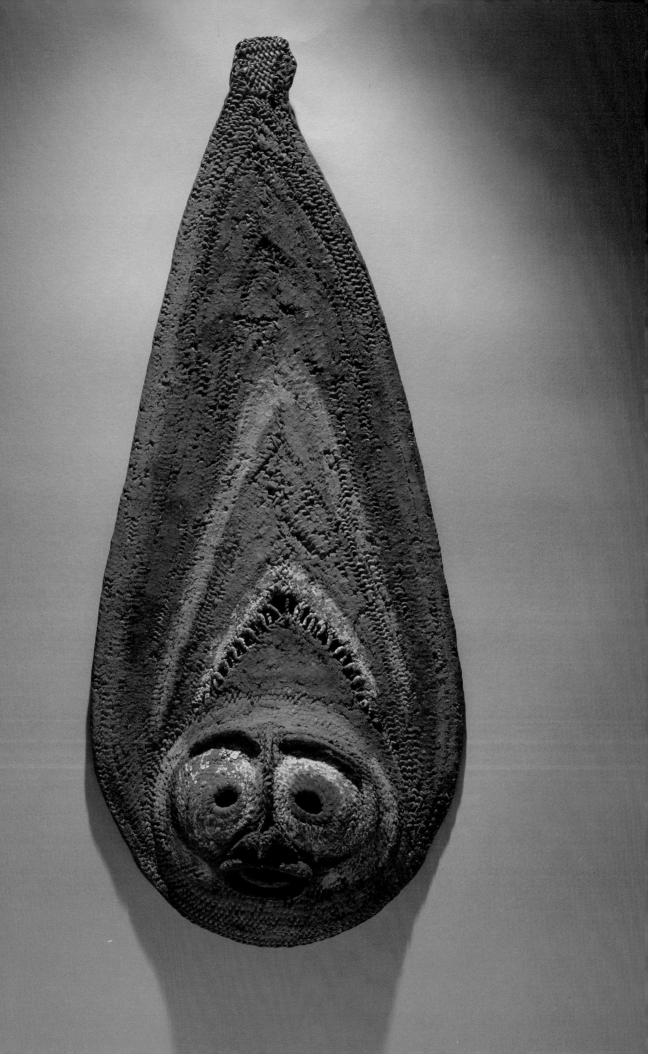

Preface

In 1984, Minnesota Museum of Art initiated a new series of exhibitions as part of a broad, trustee-mandated reassessment of its collections. Drawn primarily from the Museum's holdings, the objects in these exhibitions receive curatorial scrutiny that expands the initial inquiry from "Is this a significant object for inclusion in this exhibition?" to "Is this object appropriate and meaningful to the Museum's stated mission?"

In museums, this scrutiny is always a serious effort; it constitutes stewardship and is indeed at the heart of the curatorial function. This inquiry, however, takes on an added dimension, particularly when directed at the nearly six thousand objects from six cultures which comprise MMA's non-Western collections. Because these holdings are outside of the Museum's American focus, great care must be exercised that only the finest or especially significant objects are retained for the collection and for use.

Beginning with **AFRICAN ART: Power, Wisdom, and Passages,** ten thematic exhibitions were planned—including a few which crossed cultural boundaries such as **ANCESTORS: Links Between Worlds.** In all, almost ninety per cent of MMA's non-Western collections would be reviewed and approximately fifteen hundred objects would be exhibited over a seven-year period.

PEOPLE OF THE RIVER, PEOPLE OF THE TREE is the sixth exhibition in the series. The exhibition, this publication, and the accompanying interpretive programs, are made possible by several generous donors: National Endowment for the Arts, particularly Andrew Oliver, Director of the Museum Program; Minnesota Humanities Commission, especially Cheryl Dickson, Charles Cree and Mark Gleason; Nebraska Committee for the Humanities; Opperman & Paquin Law Firm, particularly Jerry Paquin; The Crosier Fathers and Brothers Province, Inc., and the Crosier Asmat Museum, particularly G. James Olson and Father Marcus Fleischhacker, O.S.C.

At the Museum, Associate Curator for Collections Management Leanne A. Klein bore the "lion's share" of the effort as Project Director and Curator; Leanne also edited the catalog and wrote the introduction which follows. Associate Director for Program &

Planning James J. Kamm provided oversight for the project; Curator of Collections Gloria C. Kittleson supervised preparation of the catalog and assisted with the editing; intern Eliza W. Miller, a University of Minnesota art history student, provided the Sepik catalog entries; volunteer Barbara Auch-Schwelk, Freiburg University, West Germany, assisted with the bibliography; volunteer Jeanne McCauley prepared the catalog manuscript; Curator of Exhibitions Katherine Van Tassell and MMA's Exhibition Department—David Madzo, Steven L. Stoa, Tim Peterson and Eunice Haugen—skillfully installed the exhibition; and Tim Jennen and Amy Kirkpatrick from MMA's Marketing Department were responsible for this handsome publication.

A former staff member deserves thanks as well. Joanna Baymiller, Deputy Director for Planning & Development, was instrumental in securing the National Endowment for the Arts special exhibitions grant that made the exhibition possible.

The development effort was led by Assistant Director for Development & Membership Janet Bisbee with able assistance from MMA's Partnership Program, Steve Novak, and Special Events personnel, Vice President Freddie Schutten, trustee Jay Deputy, and Ricka Robb Kohnstamm. Encouragement and on-going support for exhibitions from the Museum's collections has been a hallmark of MMA's Trustee Committee for Collections, its current chair Reverend Richard L. Hillstrom, and its chair from 1983-1988, Constance Kunin.

The ultimate beneficiaries of **PEOPLE OF THE RIVER, PEOPLE OF THE TREE** are the visitors to the exhibition; future scholars and students; you, our readers, and, indeed, the peoples of the Sepik River region and the Asmat. Through such efforts, we learn more about the lives, practices, and creative endeavors of those who live distant and apart.

M.J. Czarniecki III
Director
Minnesota Museum of Art

58. **Yam Mask /** Middle Sepik, Maprik region; Wosera people

Lenders to the Exhibition

American Museum of Natural History, New York

Maurice Bonnefoy Collection, New York

Crosier Asmat Museum, Hastings, Nebraska

Field Museum of Natural History, Chicago

Howard and Eunice Gelb

Herbert Libertson

Lowie Museum of Anthropology, University of California, Berkeley

Dr. Rhoda Metraux

The Minneapolis Institute of Arts

Department of Anthropology, The National Museum of Natural History, Smithsonian Institution, Washington, D.C.

The Science Museum of Minnesota

The University Museum, University of Pennsylvania, Philadelphia

Acknowledgments

The coordinated efforts of many individuals and organizations have gone into the development of the exhibition **PEOPLE OF THE RIVER, PEOPLE OF THE TREE: Change and Continuity in Sepik and Asmat Art,** and the preparation of its catalog. Although it is impossible to personally thank all those who have participated in the project, the Museum's Board of Trustees and staff acknowledge and appreciate the contributions made by all involved.

We are deeply grateful to three colleagues who served as consultants, principal essayists and symposium participants: Dr. Rhoda Metraux, Research Associate in Anthropology, American Museum of Natural History, New York; Tobias Schneebaum, Professor, New School for Social Research, New York, and Lecturer on Asmat Art and Culture, American Museum of Natural History, New York; and Allen Wardwell, Director, Isamu Noguchi Garden Museum, Long Island City, New York, and former Curator of Primitive Art, The Art Institute of Chicago. Without their expertise, and their warm willingness to share it with us, this exhibition and catalog could not have been possible.

The exhibition and catalog are the direct results of a collections-sharing project begun by Minnesota Museum of Art and the Crosier Asmat Museum, Hastings, Nebraska, in 1985. Forty-four superb examples of Asmat art have been placed on loan to the Museum by the Crosier Asmat Museum. Father Marcus B. Fleischhacker, O.S.C., Director of the Partners in Ministry Campaign for The Crosier Fathers and Brothers Province, Inc., Minneapolis, and the Curator of the Crosier Asmat Museum, was instrumental to the project: we thank him for selecting and transporting art works from the Crosier Collection, for serving as moderator for the symposium and speaking to the Museum's docents on Asmat art and culture, and for his unfailing encouragement and support during four years of preparation for this exhibition. Father Marcus also arranged for Bishop Alphonse A. Sowada, anthropologist and Bishop of the Diocese of Agats, Asmat, to participate in the symposium.

We also thank Howard and Eunice Gelb of Saint Paul, who donated their impressive collection of art from the Sepik River region to Minnesota Museum of Art in 1981. Works selected from this collection form the core of the exhibition and include some fine late works carved in the region during the 1960s and 1970s.

The Museum has also been fortunate in securing loans from several other private and public collections. We thank particularly the following organizations and individuals: American Museum of Natural History, New York: Dr. Craig Morris, Chairman and Curator, and Barbara Conklin, Department of Anthropology; The University Museum, University of Pennsylvania: William H. Davenport, Curator of Oceanic Art and Sherrill A.

Sanderson, Loans Administrator; the Field Museum of Natural History, Chicago: Dr. Phillip Lewis, Chairman, Department of Anthropology and Janet Miller, Archivist and Registrar, Department of Anthropology; The Minneapolis Institute of Arts: Dr. Evan M. Maurer, Director, Louise Lincoln, Curator of African, Oceanic and New World Cultures, and Karen Duncan, Assistant Registrar; National Museum of Natural History, Smithsonian Institution, Washington, D.C.: Dr. Donald Ortner, Chairman of the Department of Anthropology and Susan Crawford, Loan Coordinator; Lowie Museum of Anthropology, University of California, Berkeley: Frank Norick, Principal Museum Anthropologist and Joan Knudsen, Registrar; The Science Museum of Minnesota: Dr. Orrin C. Shane, Head of the Department of Anthropology and Todd Maitland, Curatorial Assistant; Howard and Eunice Gelb, Saint Paul; Maurice Bonnefoy, New York; Dr. Rhoda Metraux, Craftsbury, Vermont; and Herbert Libertson, New York.

A film series focusing on the theme of acculturation accompanied the exhibition. We wish to thank Dr. Orrin C. Shane, Head of the Anthropology Department at The Science Museum of Minnesota for suggesting appropriate films, and William Rowe, Ph.D., cultural anthropologist and Professor of South Asian Studies at the University of Minnesota for giving informal talks on the subject of acculturation prior to the screening of each film.

Although the entire Museum staff participated in this effort, we would like to thank several staff members, interns, and volunteers for their special contributions; they are acknowledged in the Preface.

Lastly, I would like to thank Director M.J. Czarniecki III, whose strong commitment to research and exhibit the Museum's non-Western collections has made exhibitions such as this possible.

Leanne A. Klein
Associate Curator for Collections Management

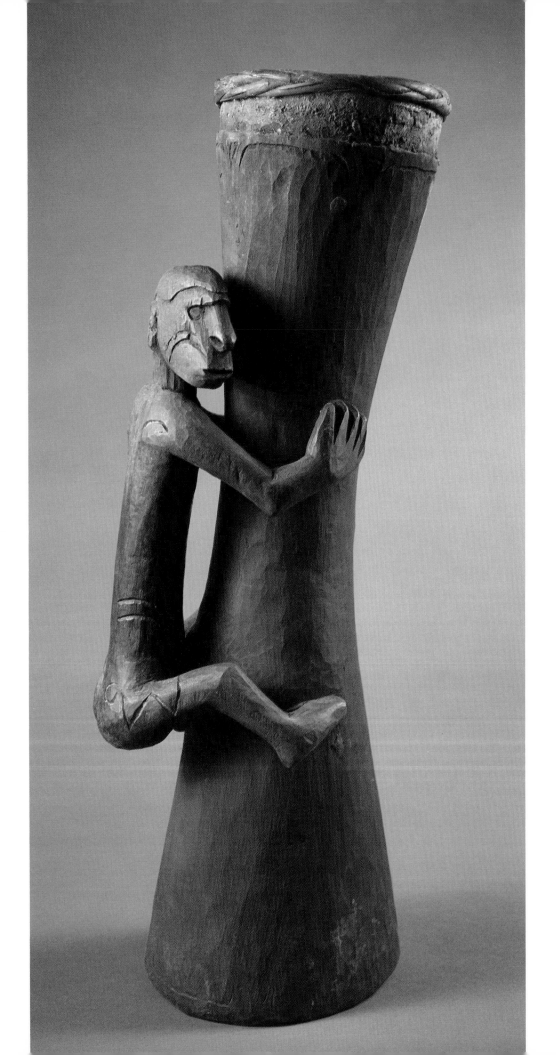

Introduction

As a central aspect of traditional culture, art is intimately bound with both that culture's general characteristics and its mundane details. Artistic content, form, and function reflect the culture as a whole, with both artists and community sharing common cultural beliefs and standards. The works that artists produce often serve as a principal means of communication among unlettered peoples. They personify, nurture, and reinforce traditional cultural values and preserve them for successive generations.

Since traditional art is so strongly conditioned by culture, sudden artistic innovations seldom occur. When changes do occur, however, they develop gradually, over a long period of time. *Acculturation*—the impact of an advanced culture on a traditional culture—occurs inexorably. While many of the culturally-sanctioned art forms and decorative motifs have been retained to this day in Sepik and Asmat art, they have been detached from their original ritual functions. Consequently, traditionally-inspired art objects are now being mass-produced for commercial sale, which are often devoid of both social and emotional content.

PEOPLE OF THE RIVER, PEOPLE OF THE TREE gathers together traditional and contemporary acculturated art works from New Guinea, the largest island in Melanesia and Oceania's major source of art works. Objects carved with traditional tools in the first half of the twentieth century are grouped together with contemporary renditions of traditional ritual art works, in order to visually document the striking changes that have occurred during the past seventy-five years. These changes are detailed and discussed in the catalog essays that follow.

Two major art producing areas of New Guinea are represented in the exhibition—the Sepik River region in Papua, New Guinea, and the Asmat. The Sepik's source is in New Guinea's central highlands. It flows in a north-easterly direction and empties into the Pacific on the island's north coast. Swampland and jungle dominate the terrain, although there are some small mountain ranges and grasslands along the upper and middle reaches of the river.

The Asmat—a term which is used interchangeably for both the land and the people—is located in southwestern New Guinea in Irian Jaya, which is part of Indonesia. The Asmat is a vast and humid swampland crisscrossed by rivers, which spreads out over an area of ten thousand square miles. Travel between villages, with populations ranging from less than one hundred to thousands, is by dugout canoe. Until they were brought under control by the Indonesian government, the Asmat were fierce head-hunters and cannibals, with a culture based on cyclic warfare and feasts which served to avenge and placate unruly ancestral spirits. For the Asmat, their art forms served as mediums between the dead and the living.

82. Drum *(em)* / Asmat people - Per village

In the 1890s, the Sepik River was located in the colony of German New Guinea and was known as the Kaiserin Augusta River. The most admirable early collections, now in Swiss and German museums, were assembled by early explorers and ethnologists in the final years of the German colonial period, between 1909-1914. Sepik culture was still intact at this time but the influx of traders, missionaries and anthropologists began shortly thereafter. By the time of the Second World War, the traditional culture had been substantially altered by Western concepts and products. Among these changes was the use of metal tools for carving Sepik "artifacts." These were primarily produced for sale to non-discriminating tourists.

Art dealers descended on the Sepik after the War and formed extensive collections comprised of both the few early works that still remained in the area and vast quantities of the new art made expressly for sale. These soon appeared on the world market and disappeared into private and institutional collections as soon as they became available. By the 1960s, the great ethnologist Alfred Bühler noted with some bitterness that Sepik culture had degenerated irretrievably and that the cults and art objects associated with it were fast disappearing.[1]

Minnesota Museum of Art's collection of Sepik art was formed during the 1970s. A major portion of it was first lent by Howard and Eunice Gelb, and subsequently given to the Museum in 1981. Most of these objects were carved with metal tools and colored with artifical pigments. Although they bear some likeness to the vital and emotionally charged carvings of the traditional culture, they are essentially tourist carvings which, when scrutinized, show the extent to which Western influence has altered the traditional culture.

Similarly, Asmat art first became known and was regarded as having artistic merit during the early years of the twentieth century. From 1904 to 1913, Dutch expeditions into the area resulted in the removal of many ritual objects carved during the old head-hunting culture and their placement in European museums. In 1953, Father G.A. Zegwaard, a Dutch missionary of the Order of the Sacred Heart, established a Catholic mission station in Asmat and in 1954, the Dutch government established an administrative post in Agats (now the capital city of Asmat). Father Zegwaard wrote extensively on the head-hunting culture and noted that the art of the people was deeply rooted in cyclic warfare and feasts, which necessitated both the taking of heads and cannibalism.

The Dutch government began the suppression of these activities, which were finally interdicted by the Indonesian government, who took control of Dutch New Guinea in 1963. The people were no longer allowed to carve in the traditional manner, feasts were banned and many men's houses were burnt and the carvings in them destroyed.

As a result of these prohibitions, the traditional art and culture of the Asmat began to disintegrate and new art forms which were more pleasing to the Western eye began to appear. The new works, carved primarily for sale to tourists, are derived from early traditional carvings, but lack their rough vitality and charismatic presence. Part of this is due to the use of new tools. In the old culture,

the main tools were stone axes and adzes. The tough leg bone of a cassowary was used as a chisel and clam shells were used to define and smooth surfaces. Today, steel knives and axes, flattened nail ends and steel chisels are widely employed.

In 1958, the Crosier Order based in Minnesota sent missionaries to the Dutch station. These missionaries encouraged the people to carve and helped them find ways to sell their carvings. The Order also formed the Crosier collection of Asmat art. Both early cult objects and striking mid-century carvings were collected, with the intention of preserving the Asmat people's cultural and artistic heritage. The Crosiers also collected art throughout the Asmat with the goal of establishing a museum in Agats. This museum would preserve the art of the people, intensify their pride in it and ensure the continuance of wood carving in the rapidly changing world of the Asmat. The Asmat Museum of Culture and Progress opened in August 1973 and serves today as an educational center, where the people learn of their past history and about the world outside.

The traditional cultures of both the Sepik River region and the Asmat have long since vanished under the influence of Western civilization. Today, these peoples have learned to doubt the worth of their own cultures and to idolize most things Western. Westerners have historically thought in terms of drawing these "primitive" cultures into a social and economic structure which would offer unlimited opportunities for social and cultural advancement. While this acculturation has been occurring, artistic activity has been strongly encouraged by both local governments and missionary orders. Although contemporary artists carve for the tourist trade, many of the traditional art forms and motifs still provide inspiration for their work.

Leanne A. Klein
Associate Curator for Collections Management

[1]Alfred Bühler, "Sepik, A Dying Culture," *Graphis* 87:68.

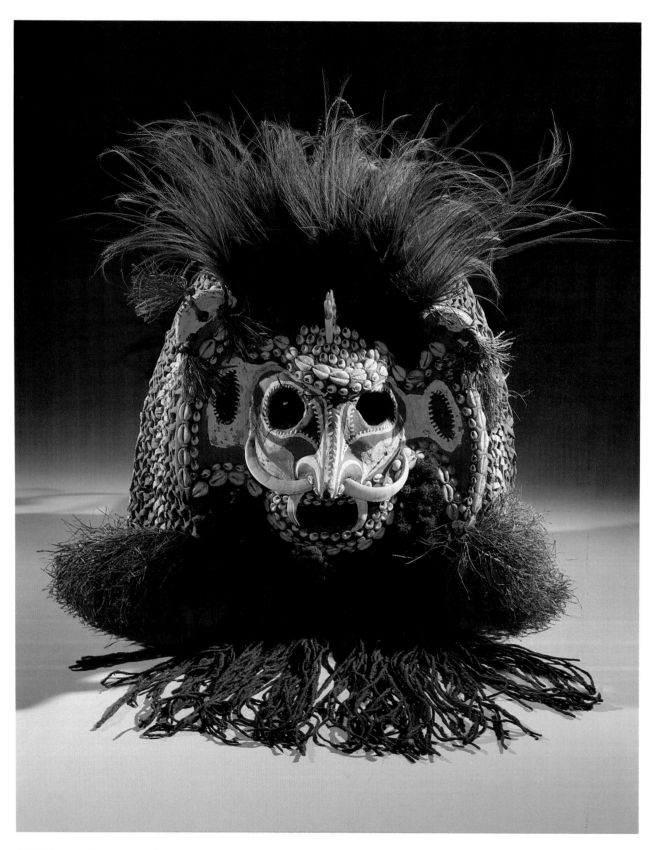

69. Helmet Mask / Lower Sepik, Angoram people

The Art of the Sepik River:
An Introduction

New Guinea, which straddles the central north coast of Australia, is the second largest island in the world. Flowing from the northern slopes of the mountainous spine in the center of the island, the seven hundred mile long Sepik River passes through various lowland environments and empties into the Pacific by way of a swampy delta on the northeast coast. The system has many tributaries, some almost as long as the Sepik itself, and the drainage includes environments of swamp, jungle, rain forest and some savannah on low hills. The entire district surrounding the river comprises twenty-six thousand square miles. It supports a population of some three hundred thousand people who live in dozens of tribal groups. Although each village is a self-contained social unit, contact between neighboring settlements is frequent.

The people subsist on agriculture, growing such crops as taro, sago, yams, bananas and coconuts. To these, supplements of fish and meat from wild and domesticated pigs are occasionally added. Such readily available sources of food fostered the development of an extraordinarily rich culture and art. The art of the Sepik River is, in fact, regarded as one of the most prolific and expressive of the entire primitive world.

Art was made to be used in elaborate ceremonies held to ensure the maintenance of social and religious traditions, and to bring success and prosperity to an individual, his family or the community at large. Rituals were performed to teach male adolescents the beliefs and history of their group so that they could become adult members, to assure the fertility of crops, animals and humans, to bring success in fishing, hunting and warfare and to ward off evil spirits and spells. Important transitions in life such as birth, name-giving, the attainment of adulthood, marriage and death were celebrated with dances, performances and other dramatic rites. Belief in animism and the worship of ancestors were practiced throughout the entire river basin and provide some continuity to the art expressions.

Much of the art served as paraphernalia for the dancers, religious practitioners and teachers during long and intricate ceremonies. The constant need for new and freshly decorated objects brought about the invention of a wide variety of expressions and fostered a technical virtuosity that is unsurpassed in Oceania. In appearance, the art is complex and dramatic, reflecting in its forms a mysterious, awe-inspiring and potentially dangerous spirit world of ancestors and animal beings that can either assist or bring harm to the people who saw and used the objects. It is characterized by bold surface ornamentation and the overemphasis of facial and physical attributes.

A sculpture might represent a single image, but often it is a combination of human and animal forms. The works are conceived in rhythmic, brooding,

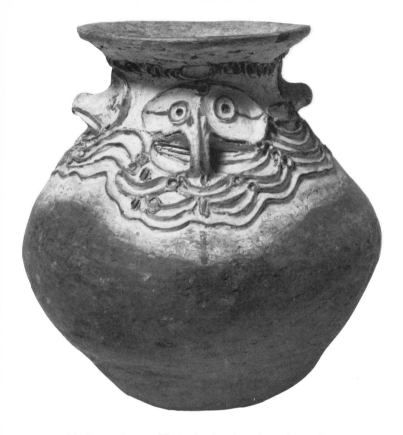

54. Storage Jar / Middle Sepik, Chambri Lakes, Aibom village

curvilinear shapes which are often further stressed with openwork areas and embellished with color and relief decoration. There is an inner tension within the forms which suggests imminent action and movement. Although essentially a wood carver's art, Sepik sculpture is further enhanced by the application of red, white, black and sometimes yellow earth pigments. Decorative additions from the local environment are attached as well, sometimes in such profusion as to obscure the form of the sculpture itself. Clay, basketry, human hair, shells of various kinds, feathers, tortoise shells, gourds, pig's tusks and animal and human teeth, bones and skulls add to the fantastic appearance of the sculpture and suggest something of the spiritual power and magic that was believed to dwell within.

Masks are among the most predominant carvings. They are in human, animal, or spirit forms and were worn at all major rites of passage. They often represented mythical or recently deceased ancestors who could give the benefit of their wisdom and success to their descendants. The dancers who wore them became possessed by these spirits, thus enabling the spirits to be present at the ceremonies. Miniature masks used as amulets were attached to clothing or hair, and tied on sacred objects to protect them from evil or exposure to the uninitiated.

Sculptures in human form served similar purposes. After they had been properly prepared and certain rituals had been performed with them, they were fit to become temporary abodes for ancestor spirits and other beings that represented supernaturals of the wood and water. Monumental figures, some larger than life size, were believed to be founders of an entire tribal lineage and benefited the community with their protective powers and influence. The smaller human sculptures were owned and cared for by families and individuals to bring success in warfare and hunting. To make them viable and attractive to spirits, the masks and figures were repainted many times, often before each use, and their decorations were renewed and replaced. This accounts for the thick patina on many of the objects. It should be remembered that much of the vegetable decoration that once adorned these pieces is now gone and what remains is faded and lacks the color and vibrant appearance it had at the time these objects were used.

A wide range of musical instruments was also made for use in ceremonial contexts. Elaborately decorated flutes, wooden trumpets, huge slit drums and drums of smaller size beaten by the hand or sounded by pounding them in the water not only provided accompaniment for rituals, but emitted sounds that were thought to represent the voices of spirits. All of these were ornamented with complex surface decorations, additional materials and sculpture. Some massive sacred flutes served only as objects of prestige and could not be played. Only initiated males had access to them and they were actually seen and used by very few.

When not in use, the ceremonial art was carefully stored in large men's cult houses which were the ritual centers of Sepik villages. These, too, were decorated with large masks, sculptures of ancestor guardians, carvings on gables, houseposts and beams. Friezes of bark paintings on the gables and walls depicted animal and human spirits.

Until quite recently, the people engaged in warfare and head-hunting and implements such as spears, arrows, daggers, clubs, spearthrowers and shields were all carved and painted with motifs that were thought to increase their effectiveness or protective powers. In essence, it can be said that almost everything used in daily life was rendered into art and none of it was secular.

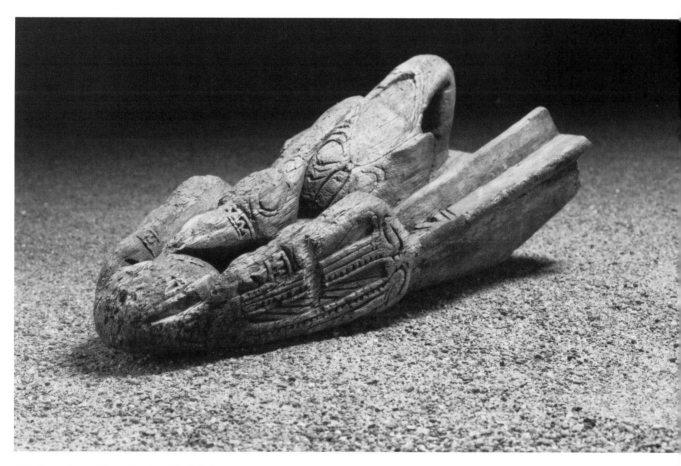

77. **Canoe Prow** / Coastal region, Murik Lakes

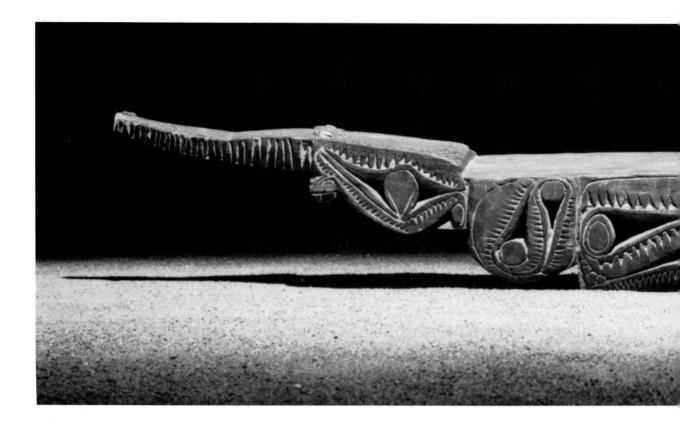

Neck rests, stools, gourds containing lime eaten with betel nut and their bone or wood spatulas were ritual art objects charged with magic. Hooks, decorated with human and animal figures, were suspended in cult houses to hold bags of food, protecting them from rodents and dirt. Small bowls for mixing pigment were carved and decorated as were canoes, their prows and paddles. The shapes and painted details of all these creations bear vivid testimony to the constant presence of the supernatural in Sepik River life. As one author has suggested, they are "the products of a world gone mad, very nearly, for art."[2]

The subject matter of Sepik art provides further emphasis of the interrelationship of the human and spirit realms. Human sculptures evoke ancestors and other human-like spirits. Creatures from the environment were incorporated into the art because their physical appearance or natural behavior suggested supernatural connections. The crocodile, for example, is a recurrent motif in the art and was respected for its stealth, patience and ability to move both on top of and under the water. It was thought to be the first ancestor of life who carried the earth up from the depths of the primeval sea providing man his land. Other common forms in the art are lizards, pigs, fish of various kinds and a number of birds such as the cockatoo, the hornbill, the frigate bird and the flightless cassowary.

Those who study these expressions carefully will note subtle differences in style which correspond to the areas along the river from which they come. The art of the coastal regions is comparatively simplified and restrained, its coloring monochromatic and less exuberantly applied than that found elsewhere. The

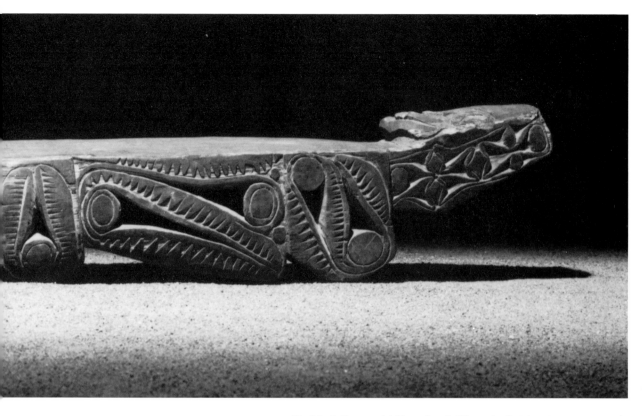

12. **Men's Ceremonial House Bench** / Upper Sepik, May River, Iwam people

lower regions of the river produced more complex, powerful and intricate forms which are enhanced with openwork and red and white coloring. Middle Sepik art is the most sophisticated, showing refined complex sculptural interrelationships of form and a graceful curvilinearity. Art from the upper regions of the river is simpler and more abstract, appearing somewhat cruder and unfinished to our eyes.

This general description of the art refers to it as it was created in the period prior to the Second World War. The great collections of it that now exist in the museums of Berlin, Berne, Basle, Cambridge, England, Chicago and Philadelphia, were all formed between the late nineteenth century and the mid 1920s when the cultures were relatively uninfluenced by the outside world. Soon after, anthropologists, missionaries, explorers and traders began to arrive in increasing numbers, and between 1940 and 1945, the war with the Japanese brought its own series of disruptions to the lower reaches of the river. By 1960, the traditional life of the area had been disrupted to such an extent that Alfred Buhler wrote, "Unfortunately the culture of the Sepik region, which has so many fine aspects, particularly as regards art and ritual, is everywhere in a state of decay . . . The traditional cults and the arts so closely connected with them are vanishing with alarming finality."[3] Only in remote inland regions of the upper river were the tribal cultures unaffected, and now these, too, are falling under the influence of the modern world.

Tourists now descend on the area looking for examples of this art and are readily provided with sculptures that have been made in studios the villagers

themselves call "carpentry shops." Usually they have been soaked in mud for several weeks to give them their "ceremonial" patina. The ancient tools with blades of stone, shell and animal teeth have long since been replaced with metal ones, and synthetic pigments often take the place of the natural earth pigments previously employed. Carving schools have been organized by missionaries and others to bring income to the people, and because they have given up their old beliefs, the motivation for the creation of the art today is wholly commercial. At its worst, it is hideous: crudely carved, slapped together from materials found at hand and without any vestige of the principles of design and form that gave this expression its great reputation.

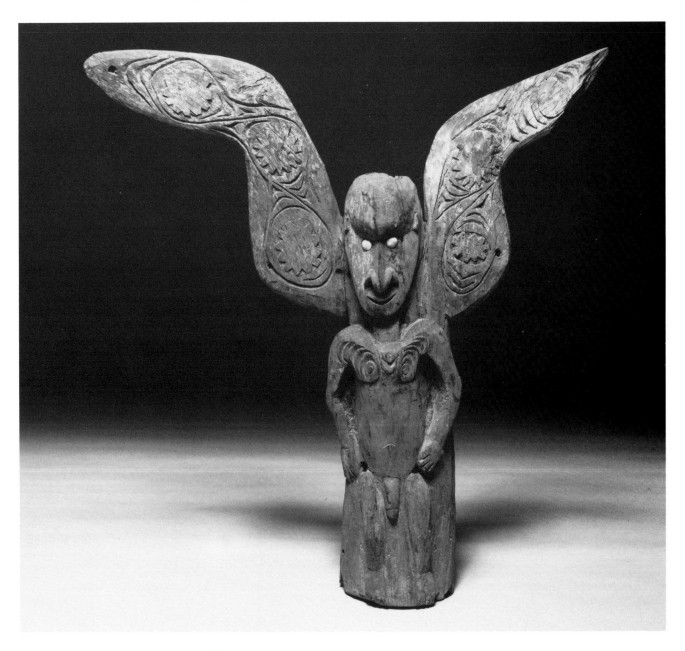

30. **Roof Finial** / Middle Sepik, Iatmul people

The art in this exhibition occupies what might be called the middle ground between the "pure" creations of the early twentieth century and the tourist-inspired work of today. A few pieces have been borrowed from early collections for the exhibition to provide a proper frame of reference for these works and to present some style areas that are not represented in Minnesota Museum of Art's collections. The Museum's pieces were all made within the last thirty years and carved with metal tools. They therefore show the extent to which acculturation had occurred by the time they were collected. Some were undoubtedly used in the proper ceremonial contexts, while those that were made for sale still bear some of the qualities of design and sculpture that mark Sepik art at its best. They can be looked upon as coming from the last period of creativity of this once dominant art producing area of Oceania. They bear within them evidence of the greatness of the earlier styles.

Allen Wardwell
Director
Isamu Noguchi Garden Museum, Long Island City, New York, and former Curator of Primitive Art, The Art Institute of Chicago

[1]Part of this text is based on the gallery brochure written by the author for the exhibition "Art of the Sepik River" for the IBM Gallery of Science and Art in 1987. Permission has been granted by IBM.

[2]Douglas Fraser, *Primitive Art* (Garden City, New York: Doubleday, 1962), 219.

[3]Alfred Bühler, "Sepik, A Dying Culture," *Graphis* 87: 68.

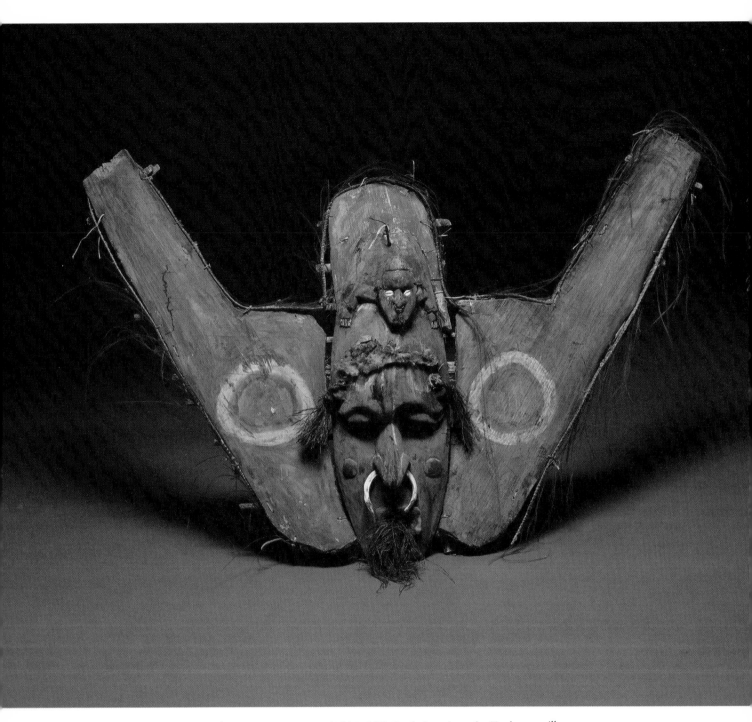

33. Canoe Prow Ornament and Protective Shield / Middle Sepik, Iatmul people - Tambunam village

Iatmul Art

Sepik River carving has been known for almost a century, ever since early German scientists, sent to explore the hinterland of the newly occupied German New Guinea, made their way up the only possible highway—the river and its lower tributaries. The finest early collections, however, were formed in the course of several Sepik expeditions in the last years of the German colonial period, between 1909-1914, in which ethnologists Otto Reche, A. Roesicke, Richard Thurnwald, and a geographer, Walter Behrmann, were the principal scientific leaders. The vast number of carvings and other objects in these collections, made in a period when Sepik carvers as yet had virtually no access to steel tools, provide the baseline in terms of how we now view—and inevitably judge—more recent work.

There is, however, a difficulty, in that one tends to think of the work known from that period as though it represents a stable, immutable life style—as though, before Europeans entered the situation, New Guineans lived in a timeless universe. In fact, carving styles were mutable, just as were fashions in dress and manners and dance performance. Even basic styles of living (although on a smaller scale than later) were continually being modified through contact among members of different cultures: through travel and trade and encounters in markets, through occasional intermarriages with outsiders, through peaceful meetings and warfare of many kinds, as well as through the natural disasters inherent in a vast river environment.

In the past, the Sepik River and its tributaries linked men in a complex, extended network of trading partnerships—enemies as well as allies—that reached far into the Sepik plains, the hill country and down to the sea, from whence came the highly valued shells that ornamented the bodies, the carvings and the houses of the Middle Sepik peoples. At the same time, the river facilitated the sudden raids through which villages competed for dominance (even among related allies), and individual men enhanced their personal reputation and that of their lineage and clan as proud, successful head-hunters. Both change and stability were very real aspects of life.

Viewed historically, the carvings and other artistic creations of a people give us special insight into their manner of initiating and responding to change—through what they hold fast and what they drop or discard, how they incorporate what is new and modify it in terms of new possibilities which they have brought from the past, and how they become newly creative. Such a dynamic view of their art brings the artists—and those for whom they worked—alive. This was very forcefully brought home to me when, after a hiatus of twenty-nine years, I followed Gregory Bateson and Margaret Mead to work in the Iatmul village of Tambunam—and was welcomed as their younger successor.

The Iatmul, some ten thousand in all, live in twenty-eight villages and small hamlets along a one hundred mile stretch on both shores of the Middle Sepik.

Although they share a common language and culture, they group themselves in three clusters of villages in accordance with minor differences in dialect. The western, upriver villages are known as the Nyaula; the central villages refer to themselves as the Palambei (the name of one existing village); and the eastern villages, of which Tambunam, the largest eastern Iatmul village, is the farthest Iatmul community downstream.

The three groups of villages—and the several villages individually also—differ somewhat in their architectural style, in their styles of music and carving, in their emphasis on certain ceremonies, in their trade and marketing relations and in their inter-village rivalries, whether in peace or at war with one another. Yet they certainly share a common set of beliefs about human—and their own—origin, and their several versions of the past are overlapping. In particular, the motifs of their carvings are shared and recur as styles change by renewal in the work of carvers in various villages. Without a very intimate knowledge of local variations in style over time—in the manner in which particular motifs are combined and new elements are incorporated—it is virtually impossible to place accurately within a village almost any single older Iatmul carving.

Traditionally, as a community of carvers, Tambunam was considered outstanding, even among the highly skilled Middle Sepik peoples. We today judge them as craftsmen and creative artists; until recently, they (somewhat like Medieval Christian artisans) saw themselves in dual roles, as capable, informed providers of ritual artifacts, on the one hand, and as prime producers of everyday artifacts, on the other. Although they admired the skill of one man's work as compared with that of another man's, what mattered in objects made for ritual performance was the implicit communication—whether the carving, specific ornamentation and brilliant painted designs were elegantly or crudely carried out.

When participants in ceremonial occasions donned the highly decorated masks and the elaborate, concealing costumes they became—not merely impersonated—the supernaturals whose roles they played. For example, the roles of elder brother, younger brother and sister in the sacred triad of the *mwai* masks implicitly referred to a basic set of personal relationships in Iatmul social life. The *mwai* ceremony, which might go on for weeks, involved several sets of players and dancers; they might be well-known performers (always men), but no one would admit knowledge of who was on stage at any time. A set of these masks—and the many other masks carved, painted and decorated for ceremonial occasions—belonged not to any individual, but to a lineage, a clan or a moiety. Some were stored in a safe and secret part of the *House Tambaran* and others in a clan or lineage men's house; still others were entrusted to the care of individual men who became responsible for their safe and secret storage in the rafters of their own houses and also, at times, for freshening them for another ceremonial appearance.

When a group of men went out into the bush to collect the fresh grasses, reeds, flowers, fruits and many other perishable materials required for a ceremonial setting and for the costumes in which masks were incorporated, they

did so in apparent secrecy. They shouted chants through their long trumpets that celebrated their task and also warned away any unintentional intruder—man, woman or child. When a major ceremony was in progress, only some of the performance was public; much else was hidden from view, as were, for example, the sacred slit gongs and flutes protected in some special enclosure or within the *House Tambaran*.

Correct ceremonial protection and handling ensured the continued existence of the inherent power of the mask or other sacred object—or, indeed, of the ceremony—to help or to harm. The first to be harmed would be those who betrayed, or who had failed in their protective role.

The attribution of power, however, was not limited to masks and other ceremonial paraphernalia. For example, the head set up in the prow of a raiding canoe—whether the sculptured skull of an ancestor or one carved in wood—was

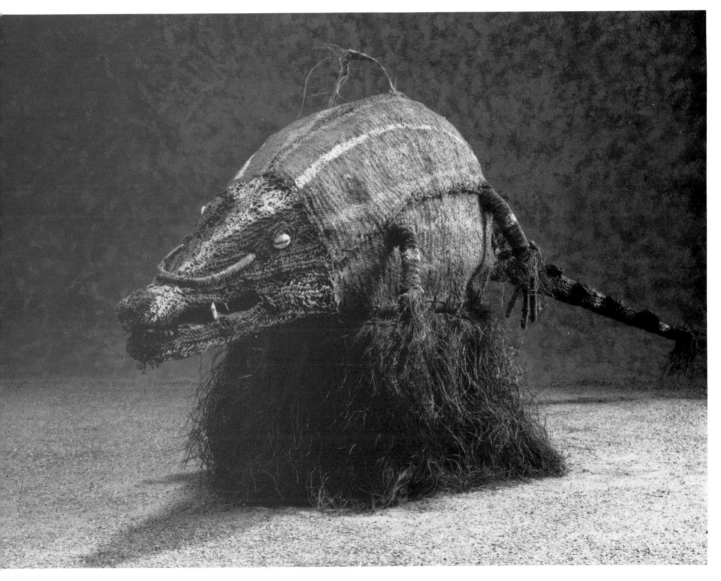

23. **Crocodile Dance Figure** / Middle Sepik, Iatmul people - Tambunam village

not only a sign that communicated to others who the raiders in the canoe were; it was also a powerful protector of the raiders' lives and a potent danger to those they raided. Similarly, the carved crocodile prow of a man's canoe (a woman's canoe did not have a carved prow) and the great crocodile through which boys crawled in fear as they entered the *House Tambaran* for initiation into manhood, not only referred to but actually were named supernatural guardians. The sacred *House Tambaran* itself was not only a manifestation of male potency, but also both a protector and a potential destroyer of each man's strength. The man who was ejected for some crime from the *House Tambaran* was immediately at risk.

This year, just over a hundred years since the early explorers first sighted Tambunam, the immense village houses and small men's houses still line the south shore. Upstream, however, in the area between Tambunam and its twin village of Wompun, there is a Roman Catholic church and until recently, on the opposite shore there was a school, where since 1953 a nun taught the children of the two villages. Still, few Tambunams became Christians. Now, for almost twenty years, the school and its playgrounds have been located across the wide Sepik — separated from the home community, but situated on land given by a Tambunam clan. The teachers are Papua, New Guineans, who grew up in distant parts of the country. Every day the children, each in a tiny canoe, paddle precariously from home toward this entrance to another world.

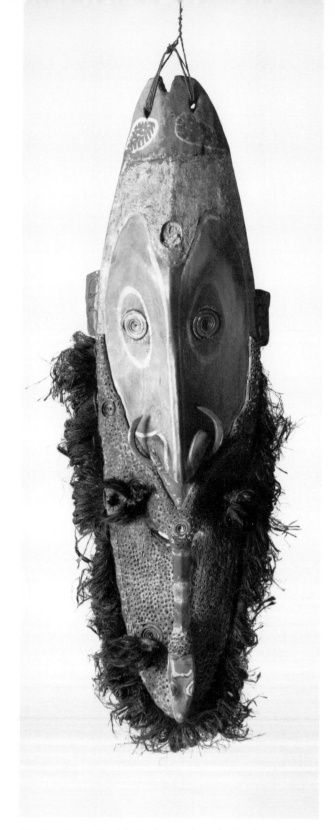

37. Mwai Mask / Middle Sepik, Iatmul people - Tambunam village

Tambunams are now citizens of a new nation; they are represented in local councils and in a government for which they have voted and to which they pay taxes for new benefits. Students have gone abroad, and one gifted Tambunam man is a professor of law in the new University of Papua, New Guinea.

16

Yet, life in the traditional sense in Tambunam goes on. Many — but not all — of the ancient, traditional ceremonies have been dropped and the great House Tambaran, destroyed by bombing in World War II, has not been rebuilt. Some of the old masks, not sold or destroyed, are still preserved and a few younger men have learned some of the old chant sequences that recount the history of Tambunam and its great men. Only rarely does one hear the flute melodies played for an end of mourning ceremony instead of contemporary music. The flute players in Tambunam, but not in every other village, still are hidden from view and women still will say, "How beautiful these bird songs are!" But, of course, they know — as perhaps they have always known — that the flutes are played and masks are worn by men.

Over the years, Tambunams have learned both to mock and cope with the traders and tourists who come to stare and also sometimes to purchase artifacts — some frankly new, others carefully aged. One year, men in every clan made copies of the heads that once were elevated on the raiding canoes, most of which were rather coarsely carved and gaudily painted. They were for sale to tourists. As the carvers explained, these pseudo-ancestor heads were a kind of a joke, but they also posed an unspoken threat directed at the tourists, who so casually roam where they please within the village.

In Iatmul villages and in distant towns, there are even today, as in the remote past, highly gifted men who experiment. Building on that past, they create something new that can no longer be called an "artifact," but rather a contemporary work of art.

Dr. Rhoda Metraux
Research Associate in Anthropology
American Museum of Natural History, New York

Catalog Entries for Selected Objects

Canoe Prows

Canoes were the primary method of transportation along the Sepik River. They played an important role both in inter-village trade and warfare and were richly decorated. If the canoe was privately owned, the degree of elaboration of the surface denoted the wealth of the owner. In some areas, the canoe was said to represent the crocodile; this echoes the Sepik origin myth which describes the sacred crocodile as the ground upon which men walk. Although some peoples believed that the intricately carved prow was essential to the success of all river excursions and that its power calmed the waves, others affirmed that the prow had only ornamental value.

There were two types of canoe prows carved in Sepik River villages—the prow in the shape of a crocodile head which extended forward from the bow of the canoe and the three-lobed canoe shield. These shields are uniform in shape and design despite regional variations in ornamentation. Some Sepik peoples thought this type of prow represented a bird with outstretched wings, while others described it as a butterfly with painted circles representing eyes on the side lobes. In some areas, reeds were attached to the lobes of the canoe shields which provided spikes upon which oranges were speared, symbolizing a successful head-hunting expedition.

E.W.M.

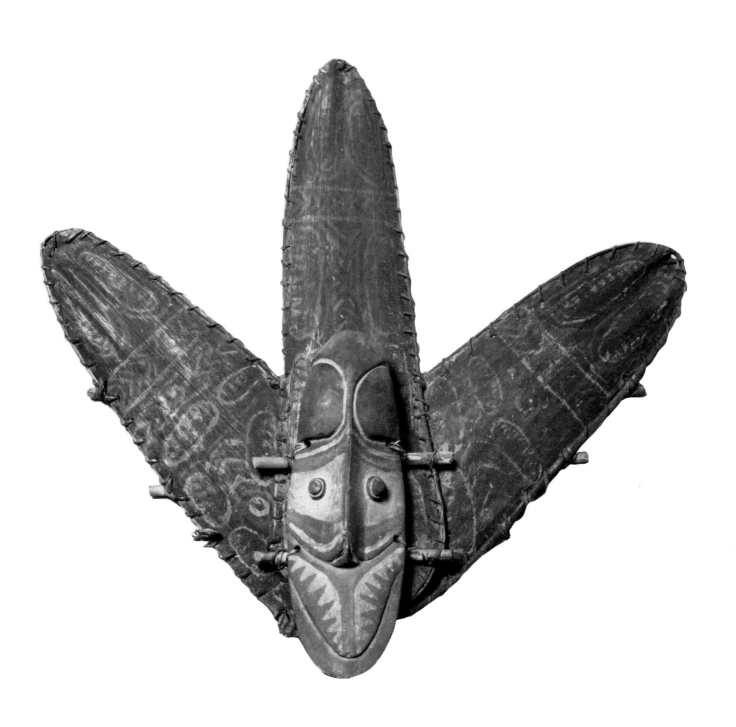

7. **Canoe Prow Ornament and Protective Shield** / Upper Sepik, May River - Iniok village

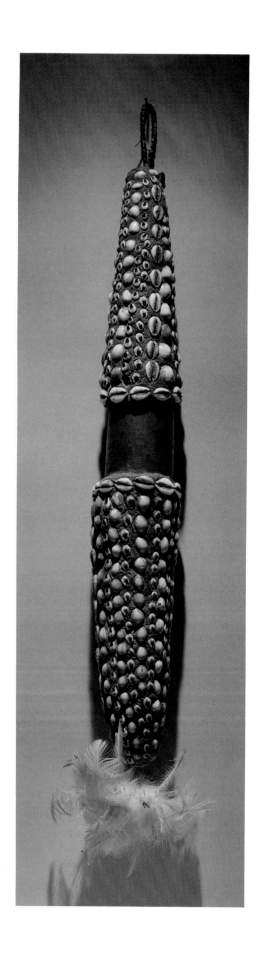

Domestic Objects

Despite their mundane use, domestic objects maintained a level of quality which rivaled that found on ritualistic carvings made by the Sepik River peoples. In the Sawos area, conical clay bowls were molded by women. This was one of their few roles in the design of secular or religious objects. The bowls were then incised and painted by men with culturally-sanctioned curvilinear designs. The Chambri Lakes area excelled in the production of large clay jars for the storage of sago which were shaped like urns with widened lips often displaying the face of bush spirits.

Lime containers were made from carved bamboo and held long spatulas which were used to remove the lime. The lime mixture was prepared by burning shell and coral and was ingested by the men as part of a habit which involved the chewing of the betel nut—an activity comparable to the smoking of cigarettes. First, a pepper leaf was placed in the mouth and then the betel nut was put in, followed by the moistened spatula dipped in the lime. At this point, the concoction was vigorously chewed, producing a flow of crimson-stained saliva. Lime container spatulas were often carved from the femur of the cassowary bird. The bulbous joint of the bone was either carved into the face of an ancestor or that of a sacred animal, such as a bird or a snake. Some were also overmodeled with the clay face of an ancestor.

E.W.M.

14. Lime Container / Middle Sepik

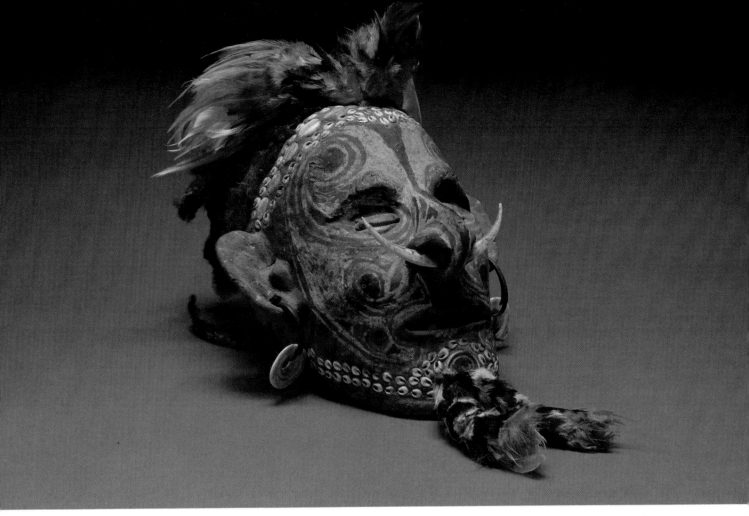

39. Ancestor Skull / Middle Sepik, Iatmul people

Skulls

Human skulls were considered essential to both ancestor worship and initiation rites by Sepik River peoples. The skull was the dwelling place of the human spirit and was respected as a source of supernatural power. Both ancestral skulls and the skulls of enemies killed in warfare were carefully preserved.

Preservation of skulls was accomplished by layering and then overmodeling the skull with clay in order to recreate the facial features of the ancestor or enemy. Burnt lime and an oil obtained from tree bark were mixed with the clay, and then the porous clay base was embedded with cowrie shells, human hair and various grasses. The skull was then painted with the curvilinear facial designs formerly worn by the deceased on ceremonial occasions.

Skulls of enemies were displayed both in the men's house and in private dwellings. They were used in consultation rites involving the sacred hook figures, as heads for dance masks and also served as trophies and prestige items for the men of the village. Ancestor skulls were worshiped in night ceremonies which involved the singing of ancestral songs and the playing of sacred flutes by the men.

E.W.M.

Dance Costumes

In the Sepik River region, dance costumes were worn during various consecration, initiation and hunting rituals. It was believed that the spirits revealed their presence through these costumes during ritual dance performances. The costumes were usually worn in pairs, by two people who danced together.

Costumes which took the shape of animals were danced ritually before embarking on hunting expeditions to kill the animals they represented. The animal was symbolically killed during the performance to ensure a successful hunt. Anthropomorphic figures represented benevolent legendary spirits. Some were danced during ceremonies consecrating new building sites to exorcise malevolent spirits from both the site and building materials. Others were danced during initiation rites to instill courage in adolescent boys about to undergo the ordeal of attaining adulthood, and prior to head-hunting raids to give courage to the warriors.

Dance costumes were intricately designed from a wide assortment of animal and vegetable materials. Rattan, feathers, wood, shells, human hair, boar's tusks and various types of fibers were normally used. The costume illustrated was created by the Iatmul people of the Middle Sepik region. The arms-akimbo stance and long, unruly hair of the figure suggest fixed motion, and the exaggerated facial features and bold face painting are further emphasized by an oversized wooden version of the traditional shell ornament placed in the nose. The costume is life-sized and hides the entire body of the dancer, thus enhancing the mystery and excitement of the dance drama.

L.A.K.
E.W.M.

22. **Dance Figure** / Middle Sepik, Iatmul people

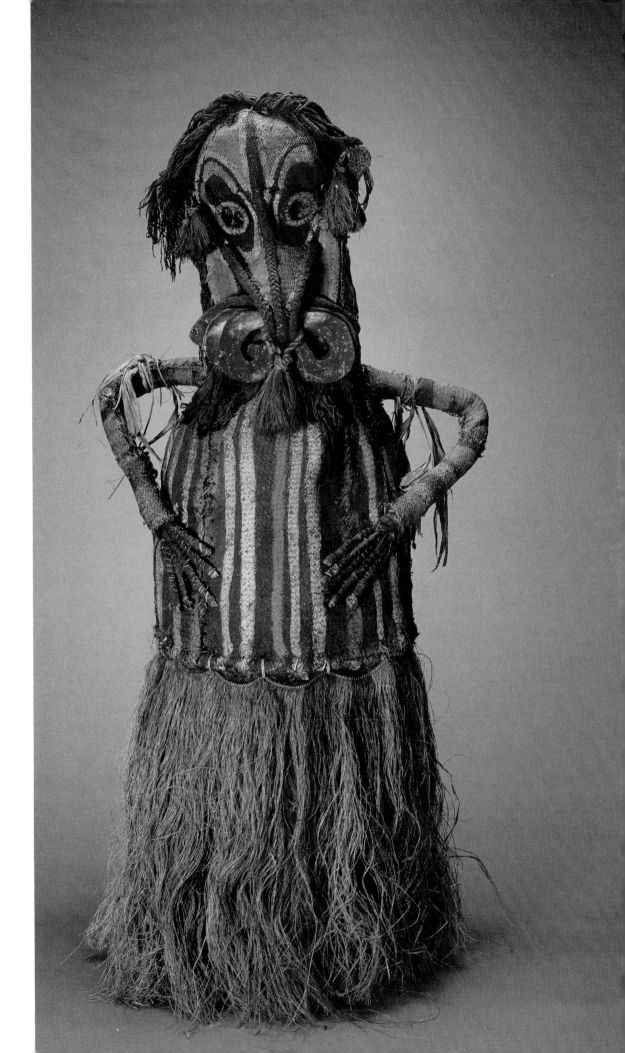

Masks

Masks played an important role in Sepik ritual life. The majority represented mythic or familial ancestors, who were called on to protect their descendants. Although some masks remained in the men's house, out of the sight of women and uninitiated boys, most were made for public viewing during village ceremonies. They were normally worn as part of a dance costume and celebrated adolescent initiation rites, harvests, rituals held prior to the hunt or intertribal warfare, name-giving ceremonies, birth and death. They were stored between festivals in the *House Tambaran* (men's house).

Masks were originally made of leaves, but later were fashioned from rattan or carved from wood. They were lavishly decorated with all types of animal and vegetable materials—shells, feathers, seeds, boar's tusks, clay and bone. Masks in the Maprik region were tightly and delicately woven from rattan, which was carefully braided in concentric circles for eyeholes and for latticed edging. Used in ceremonies associated with the yam cult, the masks were either placed on the yam itself or worn by dancers during festivals celebrated to ensure fertility of the crops. Sepik masks used in ritual were bold and dynamic; they were meant to be seen in motion during dances or dramatic presentations which recounted tribal history, mythology and ancestral lore for the people.

Many of these masks are distinguished by long, exaggerated noses. The phallic symbolism of these noses connotes fertility and emphasized the sexual differences between men and women during the initiation ceremonies, in which many of these masks were worn. The noses also often terminate in the head of a snake or a bird's head and beak. Masks with these types of noses represent the animal ancestor of a clan or individual and suggest the totemic relationship between man and animal.

E.W.M.

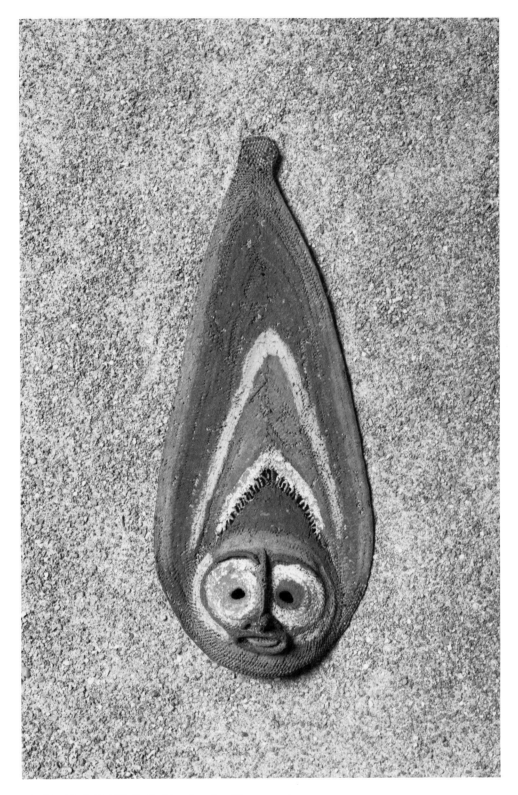

58. Yam Mask / Middle Sepik, Maprik region, Wosera people

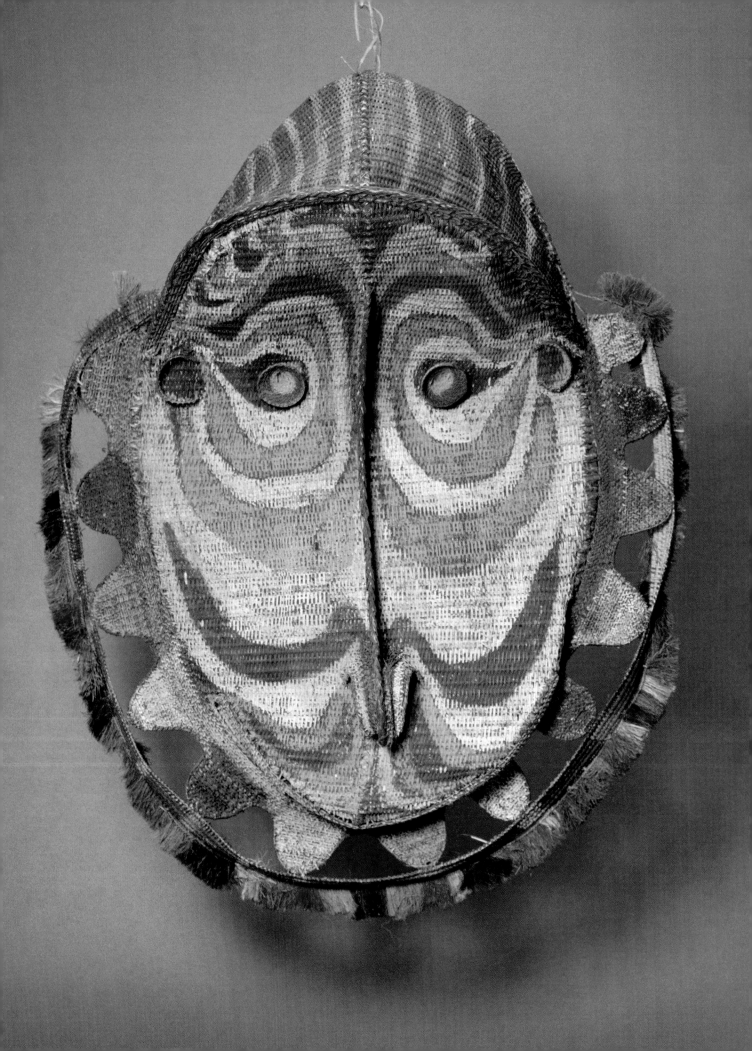

Gable Masks

Large gable masks dominated the spaces over the doorways of both the men's ceremonial houses and traditional dwellings. Although gable masks were thought to represent ancestral tribal spirits throughout the Sepik River region, the precise function of these spirits varied from village to village. In some areas, gable masks were considered to be legendary tribal guardians, who oversaw the domicile and maintained domestic tranquility and fertility. In other regions, the gable mask was thought to be the primal ancestral woman; the entire men's house represented the body of this woman and established a daily connection between men and their mythic origin. It was believed that she provided protection from disaster to all who lived under that roof.

The masks were made either of woven and plaited rattan, carved wood, or a combination of both. Both types of masks were elaborately painted with designs typical of ceremonial face-painting. On both the woven and wooden masks, a zig-zag shaped border appears, similar to the decoration on ceremonial shields representing crocodile teeth. The wooden masks were often outlined with various kinds of shells and bordered with feathers from the cassowary or another sacred bird, and the rattan masks were adorned with fringes of grasses and other fibers.

E.W.M.

59. **Gable Mask** / Middle Sepik, Blackwater River, Kaninggara people - Kuvenmas village

Shields

Shields were found throughout the Sepik River region and assumed various ceremonial and practical functions from people to people. The Iwam people from the Upper Sepik region used shields in both warfare and ceremony, whereas the Iatmul people of the Middle Sepik region, who waged war in canoes, found shields cumbersome and seldom used them.

Shield making was a five-step process which was passed down through families, with the father or an uncle of a newly initiated boy teaching him to carve the traditional shapes and apply the surface decoration. A log was first split and then charred to produce an even, dark surface upon which a design was drawn in white clay. The design was then carved into the surface with tools made from animal teeth and shells, and painted with natural pigments. White paint was mixed from quicklime, black from charcoal, and yellows and reds from various earth pigments.

The war shield illustrated was carved by the Biwat people of the Lower Sepik region. The body is slightly curved and is decorated at the long sides with raffia and at the top with cassowary feathers. The low relief surface on the front of the shield is dominated by three highly stylized faces, which are linked together by jagged, decorative bands. The corners of the eyes have been extended to form wings. As is invariably the case with shields, the faces represent spirits which are associated in some way with the man who bears the shield. Their duty is to protect the shield bearer in warfare by giving him superhuman strength and by frightening away the enemy.

E.W.M.
L.A.K.

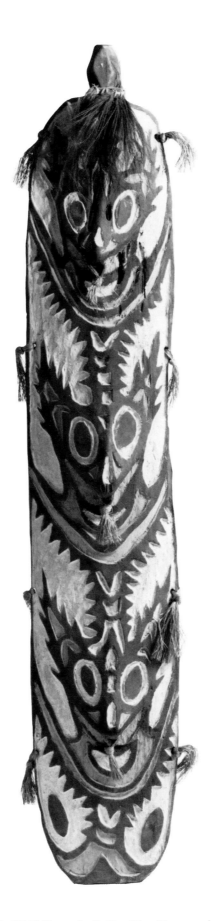

70. Shield / Lower Sepik, Yuat River, Biwat people

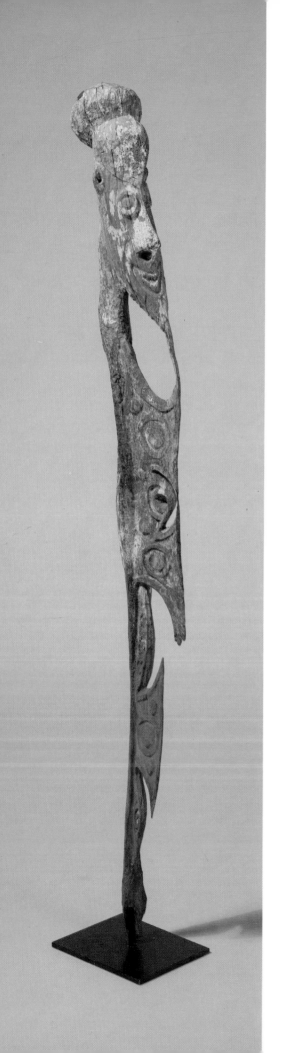

Hook Figures

 Hook figures are perhaps the most intriguing and certainly the most complex of the carvings made by the people of the Sepik River region. The oldest hook figures, such as those which lay undisturbed in the caves of the Karawari River for over two hundred years, show a subtlety and equality of elements that is no longer apparent in more recent figures. Hook figures generally consist of an elongated oval head set upon an abdominal area bristling with spines and prongs, which is attached to a sturdy spine. This spine is elevated by a leg and foot, or, more rarely, a leg and two feet. More recent hook figures display the same elements, but the abdominal arcs are completely symmetrical

67. **Hook Figure** *(aripa)* / Middle Sepik, Karawari River, Ewa people

and new anatomical attributions such as ribs, hearts and penises are strongly evident. All generations of hook figures were made to be viewed in profile.

These figures, although individually owned, were kept in the dim recesses of the men's house, well-concealed from the eyes of the uninitiated. The figures, which merely represented the spirits after which they were named (as opposed to actually *being* those spirits), were crucial to the success of a hunt for game or a head-hunting expedition. In order for the spirits to be entreated to aid the men, the figures had to be "warmed up" during the days preceding the hunt.

The "heating up" process involved rubbing the figures and the men with various plants, roots and leaves, dried flesh from a previous hunt, and various body fluids from the men. This placed both the spirits and the men into a trance-like state, which could last for a number of days.

If the hunt was successful, the hook figure was rubbed with copious amounts of blood from the victim's head. The victim's flesh was preserved as a magical substance and the skull overmodeled with clay. An unsuccessful raid or hunt ended with the discarding of the uncooperative hook figures and the carving of new and hopefully more propitious figures.

E.W.M.

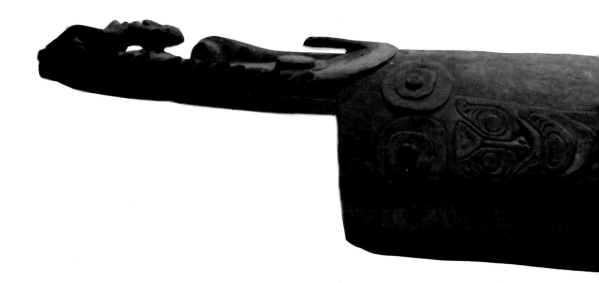

Drums

Drums were prevalent in the Middle Sepik and Coastal regions, the Upper Sepik and many of the Sepik tributary river areas. They played an important part in both public and private ceremonies held in the Sepik River region. Three types of drums were made; the dance drum, which was played during public ceremonies; the water drum, which was left in swamps and played to appease the water spirits and calm the river waters; and the slit gong, the most sacred of all the drums.

The slit gong, made from a hollowed out log, has a horizontal opening carved into the top side. These huge drums were played to send messages from village to village, to call meetings and to impersonate the voices of the spirits for the uninitiated and as accompaniment for ritual singing and dancing. Each village had its distinctive manner of drumming.

Drums belonged to specific clans and were stored in the men's houses, hidden from women and uninitiated boys. They were thought of as animals (most particularly, the crocodile) and many also featured human faces combined with animal faces. These animals might have been mythological ancestors of kinship groups, while the human faces may have represented the primeval giant in a Sepik creation myth.

E.W.M.

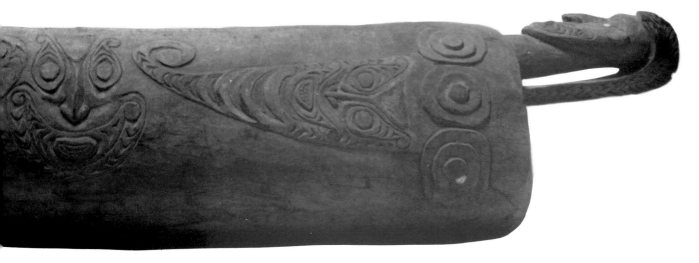

34. Slit Gong with Beaters *(garamut)* / Middle Sepik, Iatmul people

The Men's House

The *House Tambaran* (men's house) was the spiritual center of the Sepik village and the focal point of the religious cults of ancestor and spirit worship. It was the site of sacred ceremonies which honored ancestors, placated local spirits, consecrated and named carvings and initiated adolescent boys. It emphasized the separation of the sexes, and was completely off-limits to women and uninitiated boys.

Although each village had a men's house, their numbers and building styles varied according to the region of the Sepik in which they were located. The houses were typically very long—some spanning hundreds of yards and rising fifty feet high—and in a sense established an elevated corridor within the village. Roofed with rough thatching, the house personified the primeval crocodile from the Sepik origin myth. According to myth, the earth was originally covered with water. The crocodile rose from the depths to the surface and his back formed the land. The annual floods of the Sepik River reinforce this image; the long roofs of the men's houses lie placidly above the water, resembling recumbent crocodiles.

The houses were divided into two stories of differing levels of sanctity. The first story was open at both ends, and sacred drums, ancestral figures or panels, skull boards and fireplaces were placed in the dimly lit space. In the center of the space, the ceremonial or orator's chair was placed. The chair bore an ancestral figure and the seat of it was struck from time to time with leaves by villagers who spoke of myths and clan history in proximity to it. The upper level of the house was the most sacred space; access was achieved only by mounting a ladder and climbing through the splayed legs of an enormous female figure. She was the ancestral woman, the one from whom all men came to the earth, according to another Sepik creation myth.

E.W.M.

53. Interior Panel for Men's Ceremonial House / Middle Sepik, Chambri Lakes, probably Aibom village

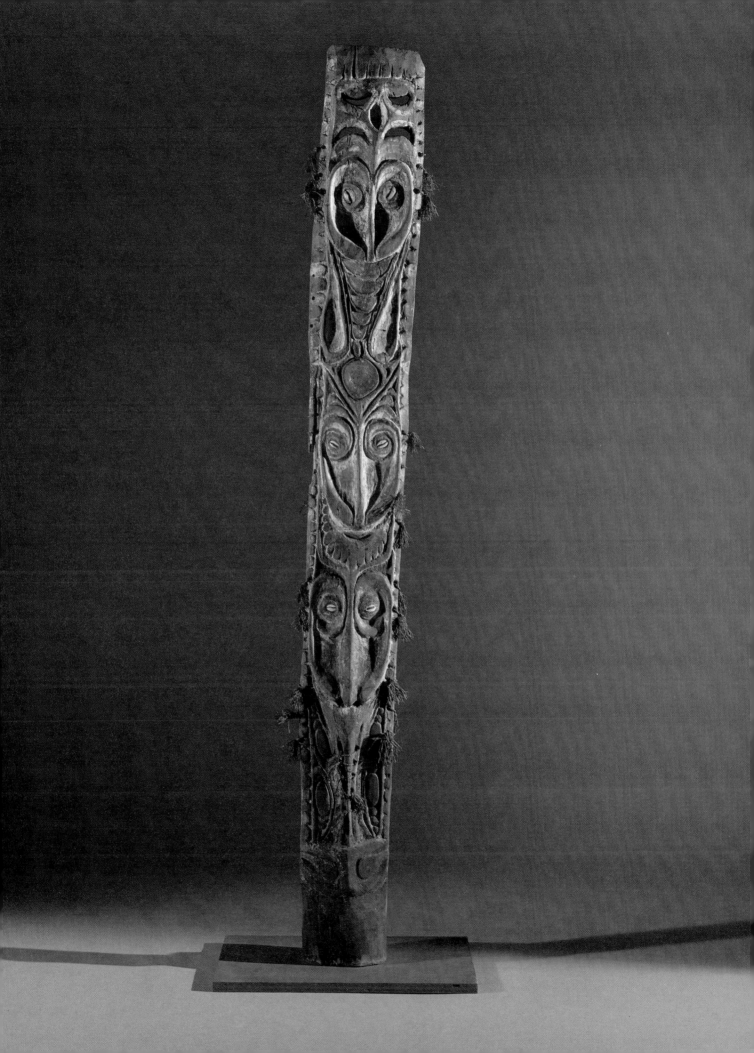

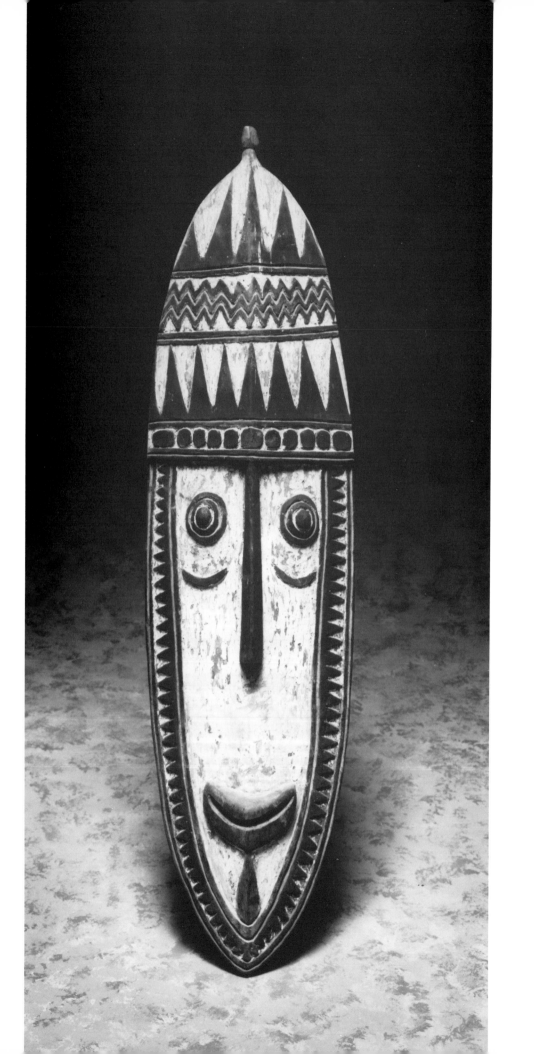

Checklist

The Upper Sepik River

1. Artist Unknown, Papua, New Guinea, Sepik River region
Upper Sepik, April River area, Iwam people
War Shield
wood, paint
84 x 24 ½ x 1
Gift of Howard and Eunice Gelb
79.15.05

2. Artist Unknown, Papua, New Guinea, Sepik River region
Upper Sepik, Green River area
Ceremonial Shield
wood, paint, cane
64 ½ x 19 ¾
Acquisition Fund Purchase
73.56.06

3. Artist Unknown, Papua, New Guinea, Sepik River region
Upper Sepik, April River, Nggala people - Swagup village
Dance Shield
wood, paint
48 x 10 ½ x ¾
Gift of Howard and Eunice Gelb
79.15.103

4. Artist Unknown, Papua, New Guinea, Sepik River region
Upper Sepik, April River, Nggala people - Swagup village
Dance Shield
wood, paint
40 x 11 ¾ x 4
Gift of Howard and Eunice Gelb
79.15.109

5. Artist Unknown, Papua, New Guinea, Sepik River region
Upper Sepik, April River, Nggala people - Swagup village
Dance Shield
wood, paint
74 ½ x 20 x ¾
Gift of Howard and Eunice Gelb
79.15.90

6. Artist Unknown, Papua, New Guinea, Sepik River region
Upper Sepik, May River - Tauri village
Canoe Prow
wood, paint
29 x 11 ½ x 3 ½
Gift of Howard and Eunice Gelb
79.15.139

7. Artist Unknown, Papua, New Guinea, Sepik River region
Upper Sepik, May River - Iniok village
Canoe Prow Ornament and Protective Shield
wood, paint, fiber
43 x 41 x 4
Gift of Howard and Eunice Gelb
79.15.124

8. Artist Unknown, Papua, New Guinea, Sepik River region
Upper Sepik, Hunstein Mountains
Cult Hook
wood, paint
13 ½ x 33 x 2
Gift of Howard and Eunice Gelb
79.15.80

9. Artist Unknown, Papua, New Guinea, Sepik River region
Upper Sepik, May River
Penis Shield
coconut shell, fiber
4 ¾ x 2 ¼ x 2 ¼
Gift of Howard and Eunice Gelb
79.15.42

10. Artist Unknown, Papua, New Guinea, Sepik River region
Upper Sepik, May River
Penis Shield
fiber, paint
14 ¼ x 2 x 2
Gift of Howard and Eunice Gelb
79.15.36

11. Artist Unknown, Papua, New Guinea, Sepik River region
Upper Sepik, Hunstein Mountains, Bahinemo people
Spirit Cult Board
wood
37 x 12 x 2 ¼
Gift of Howard and Eunice Gelb
79.15.23

12. Artist Unknown, Papua, New Guinea, Sepik River region
Upper Sepik, May River, Iwam people
Men's Ceremonial House Bench
wood, shells
12 x 83 x 11
Gift of Howard and Eunice Gelb
79.15.09

4. **Dance Shield** / Upper Sepik, April River, Nggala people - Swagup village

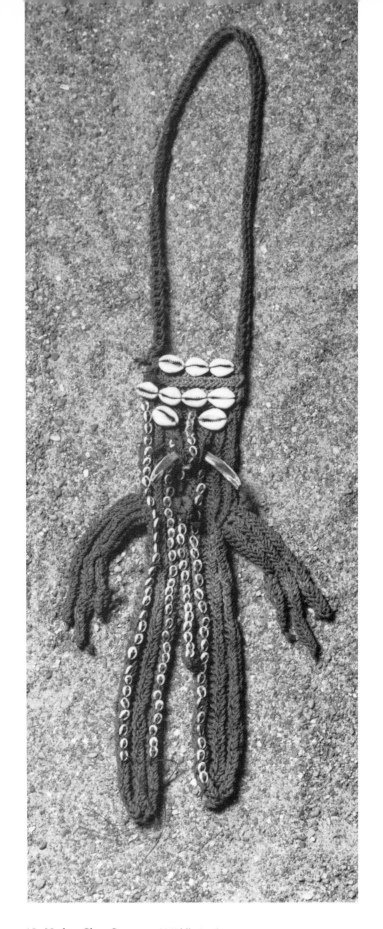

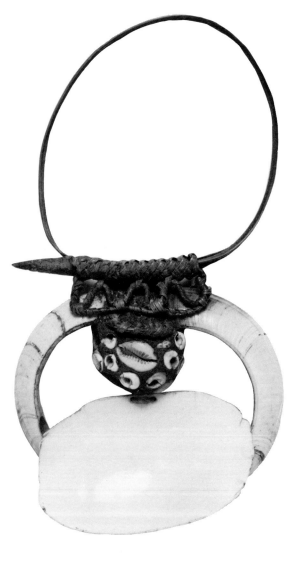

15. Neck or Chest Ornament / Middle Sepik

16. Neck or Chest Ornament / Middle Sepik

The Middle Sepik River

13. Artist Unknown, Papua, New Guinea,
Sepik River region
Middle Sepik
Yam Digger
wood, paint, shells, human hair, cassowary
feathers
23 ½ x 4 x 1 ½
Gift of Howard and Eunice Gelb
79.15.192

14. Artist Unknown, Papua, New Guinea,
Sepik River region
Middle Sepik
Lime Container
gourd, clay, cowrie shells, tambu shells,
feathers
18 x 2 ¾ x 3
Gift of Howard and Eunice Gelb
79.15.168

15. Artist Unknown, Papua, New Guinea,
Sepik River region
Middle Sepik
Neck or Chest Ornament
fiber, shells, boar's tusk
21 x 8 ½ x 1 ½
Gift of Howard and Eunice Gelb
79.15.230

16. Artist Unknown, Papua, New Guinea,
Sepik River region
Middle Sepik
Neck or Chest Ornament
shells, clay, boar's tusk, fiber
9 x 5 x ¾
Gift of Howard and Eunice Gelb
79.15.225

17. Artist Unknown, Papua, New Guinea,
Sepik River region
Middle Sepik
Spears and Bow
bamboo, paint
Average length: 65
Gift of Howard and Eunice Gelb
79.15.114

18. Artist Unknown, Papua, New Guinea,
Sepik River region
Middle Sepik, Wambun village
Food Dish
earthenware
8 ½ high, 13 ¼ diameter
Collection of The Minneapolis Institute of
Arts
The Putnam Dana McMillan Fund
74.79.4

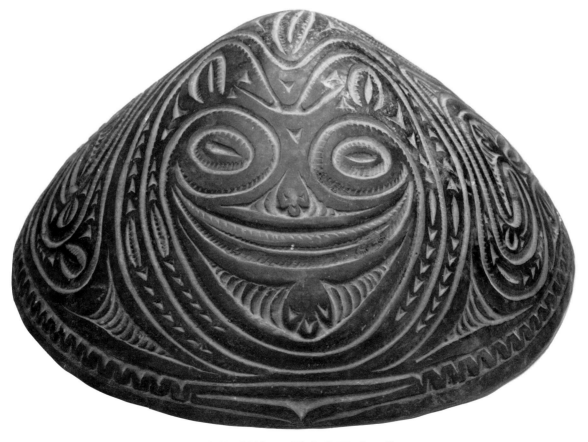

39

18. Food Dish / Middle Sepik, Wambun village

The Middle Sepik River—
Iatmul People

19. Artist Unknown, Papua, New Guinea,
Sepik River region
Middle Sepik, Iatmul people
Cassowary Bird Bone Dagger
cassowary bone, incised with spiral designs
15 x 2 x 2
Gift of Howard and Eunice Gelb
79.15.250

20. Artist Unknown, Papua, New Guinea,
Sepik River region
Middle Sepik, Iatmul people
Mwai Mask
wood, clay inlaid with tambu, cowrie and
snail shells, boar's tusk, paint, human hair,
fiber
33 ½ x 6 x 5 ¾
Gift of Howard and Eunice Gelb
79.15.216

21. Artist Unknown, Papua, New Guinea,
Sepik River region
Middle Sepik, Iatmul people
Pig Skull
pig skull, overmodeled clay inlaid with tambu
and cowrie shells, paint, cassowary feathers,
bone
18 x 8 x 5
Gift of Howard and Eunice Gelb
79.15.171

22. Artist Unknown, Papua, New Guinea,
Sepik River region
Middle Sepik, Iatmul people
Dance Figure
rattan, paint, fiber, wood
49 x 41 x 24
Gift of Howard and Eunice Gelb
79.15.146

23. Artist Unknown, Papua, New Guinea,
Sepik River region
Middle Sepik, Iatmul people - Tambunam
village
Crocodile Dance Figure
rattan, paint, fiber, shells, boar's tusk
15 ¾ x 88 ⅜ x 13
Gift of Howard and Eunice Gelb
79.15.134

24. Artist Unknown, Papua, New Guinea,
Sepik River region
Middle Sepik, Iatmul people - Chambri Lakes
area
Shield
wood, paint traces
71 ½ x 16 ½ x 1 ½
Gift of Howard and Eunice Gelb
79.15.117

25. Artist Unknown, New Guinea, Sepik
River region
Middle Sepik, Iatmul people - Kamindibit
village
Standing Figure
wood, paint, shells, fiber, cassowary feathers
71 x 13 x 5
Gift of Howard and Eunice Gelb
79.15.70

26. Artist Unknown, New Guinea, Sepik
River region
Middle Sepik, Iatmul people - Tambunam
village
Cassowary Dance Figure
rattan, cassowary feathers, paint, fiber, shells
38 x 65 x 12
Gift of Howard and Eunice Gelb
79.15.105

27. Artist Unknown, Papua, New Guinea,
Sepik River region
Middle Sepik, Iatmul people
Leg Ornament
fiber, shells, feathers, paint
6 x 6 x 3 ¼
Gift of Howard and Eunice Gelb
79.15.227

28. Artist Unknown, Papua, New Guinea,
Sepik River region
Middle Sepik, Iatmul people - Kanganaman
village
Stool
wood, paint traces
31 x 15 ½ x 13 ½
Gift of Howard and Eunice Gelb
79.15.132

29. Artist Unknown, Papua, New Guinea,
Sepik River region
Middle Sepik, Iatmul
Flute Finial
bamboo, wood, paint, rattan, shells
31 x 2 ½ x 2 ½
Gift of Howard and Eunice Gelb
79.15.204

30. Artist Unknown, Papua, New Guinea,
Sepik River region
Middle Sepik, Iatmul people
Roof Finial
wood, shells, fiber
37 x 34 x 9
Gift of Howard and Eunice Gelb
79.15.86

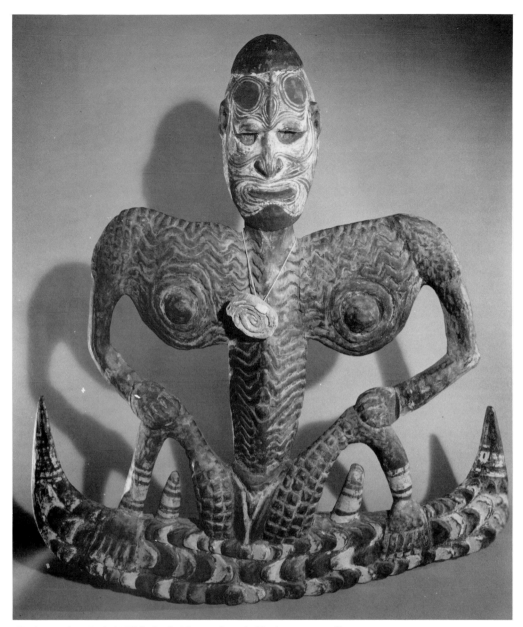

40. Suspension Hook / Middle Sepik, Niyaura Iatmul - Yenshamanggua village

31. Artist Unknown, Papua, New Guinea,
Sepik River region
Middle Sepik, Iatmul people - Korogo village
Female Suspension Hook
wood, paint, tambu and cowrie shells, human
hair
42 x 16 ½ x 4 ½
Gift of Howard and Eunice Gelb
79.15.58

32. Artist Unknown, Papua, New Guinea,
Sepik River region
Middle Sepik, Iatmul people
Woven Pig
wood, rattan, fiber, cassowary feathers, paint,
cowrie shells
12 x 30 x 8
Gift of Howard and Eunice Gelb
79.15.21

33. Artist Unknown, Papua, New Guinea,
Sepik River region
Middle Sepik, Iatmul people - Tambunam
village
Canoe Prow Ornament and Protective Shield
wood, paint, fiber, cassowary feathers,
marsupial fur, boar's tusk, shells
30 x 54 x 7
Gift of Howard and Eunice Gelb
79.15.01

34. Artist Unknown, Papua, New Guinea,
Sepik River region
Middle Sepik, Iatmul people
Slit Gong with Beaters (garamut)
wood, fiber, shells
drum: 18 ½ x 111 x 14 ⅛
beaters: 35 ½ long, 6 ⅞ diam.
Gift of Howard and Eunice Gelb
79.15.24

The Middle Sepik River — Iatmul People (cont'd)

35. Artist Unknown, Papua, New Guinea, Sepik River region
Middle Sepik, Iatmul people - Tambunam village
Gable Mask
wood, paint, raffia, fiber, cassowary feathers, cowrie shells
44 ½ x 12 x 3
Gift of Howard and Eunice Gelb
79.15.210

36. Artist Unknown, Papua, New Guinea, Sepik River region
Middle Sepik, Iatmul people - Kanganaman village
Stool
wood, fiber, paint traces
15 ½ x 16 ½ x 17 ½
Gift of Howard and Eunice Gelb
79.15.02

37. Artist Unknown, Papua, New Guinea, Sepik River region
Middle Sepik, Iatmul people - Tambunam village
Mwai **Mask**
wood, clay, paint traces, fiber, boar's tusk, cowrie shells, conus shells, tambu shells, feathers
53 x 14 x 8
Gift of Howard and Eunice Gelb
79.15.12

38. Artist Unknown, Papua, New Guinea, Sepik River region
Middle Sepik, Iatmul people
Men's Ceremonial House Support Post
ironwood
155 x 19 ¼ x 14 ¼
Gift of Howard and Eunice Gelb
79.15.14

39. Artist Unknown, New Guinea, Sepik River region
Middle Sepik, Iatmul people
Ancestor Skull
human skull overmodeled with clay, human hair, shells, paint, feathers, boar's tusk
8 x 7 x 10
Collection of Howard and Eunice Gelb

40. Artist Unknown, Papua, New Guinea, Sepik River region
Middle Sepik, Niyaura Iatmul - Yenshamanggua village
Suspension Hook
wood, paint
39 ⅛ x 35 ¹⁄₁₆ x 5 ¹¹⁄₁₆
Collected by Captain H., about 1914
Collection of The University Museum, University of Pennsylvania, Philadelphia
29.50.334

41. Artist Unknown, Papua, New Guinea, Sepik River region
Middle Sepik, Iatmul people - Tambunam village
Woman's Carrying Bag
basketry
19 x 20
Collected in 1972
Collection of Dr. Rhoda Metraux

42. Artist Unknown, Papua, New Guinea, Sepik River region
Middle Sepik, Iatmul people - Tambunam village
Man's Carrying Bag
basketry
17 ½ x 11
Collected in 1972
Collection of Dr. Rhoda Metraux

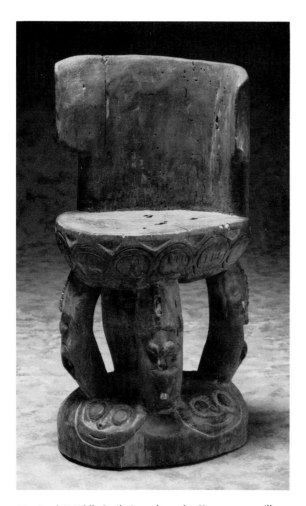

28. Stool / Middle Sepik, Iatmul people - Kanganaman village

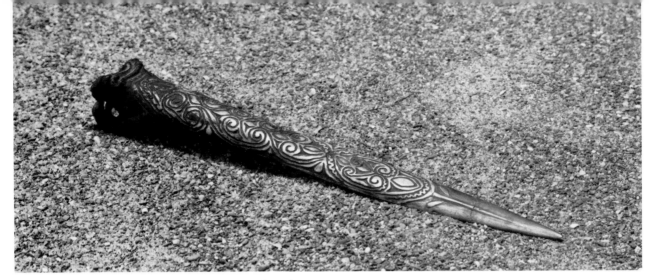

19. **Cassowary Bird Bone Dagger** / Middle Sepik, Iatmul people

43. Artist Unknown, Papua, New Guinea, Sepik River region
Middle Sepik, Iatmul people - Tambunam village
Mask. Modern version of a traditional style.
wood, paint, shells
17 x 7 ½ x 4
Collection of Dr. Rhoda Metraux

44. Artist Unknown, Papua, New Guinea, Sepik River region
Middle Sepik, Iatmul people - Tambunam village
Mask. Modern version of a traditional style.
wood, clay, paint, shells, raffia, teeth
19 ¾ x 8 ½ x 4
Collection of Dr. Rhoda Metraux

45. Artist Unknown, Papua, New Guinea, Sepik River region
Middle Sepik, Iatmul people - Tambunam village
Figure Carving. A "practice figure."
wood, paint
12 x 2 x 2
Collection of Dr. Rhoda Metraux

46. Artist Unknown, Papua, New Guinea, Sepik River region
Middle Sepik, Iatmul people - Tambunam village
Miniature Mask Pendant
wood, metal chain
6 ½ x 2 ¼ x 1
Collection of Dr. Rhoda Metraux

47. Artist Unknown, Papua, New Guinea, Sepik River region
Middle Sepik, Iatmul people - Tambunam village
Miniature Mask Earrings
wood, paint
3 x 1 x ½ (each)
Collection of Dr. Rhoda Metraux

48. Artist Unknown, Papua, New Guinea, Sepik River region
Middle Sepik, Eastern Iatmul - Tambunam village
Miniature Fish Trap (Namwi ngwisingai)
palm leaf fiber
19 ½ long, 10 ½ diameter
Collected in 1972
Collection of the American Museum of Natural History, New York
80.1/6823

49. Artist Unknown, Papua, New Guinea, Sepik River region
Middle Sepik, Ankerman style (perhaps made by Tambunam carver living in Angoram)
Mask-like Carved Ornament
wood, cowrie shells
14 x 9 x 2
Purchased in Angoram, July, 1972
Collection of the American Museum of Natural History, New York
80.1/6892

50. Artist Unknown, Papua, New Guinea, Sepik River region
Middle Sepik, Eastern Iatmul - Tambunam village
Mask-like Carved Ornament. Contemporary *mwai* type.
wood, clay, shell, fiber
25 x 7 ½ x 10
Collected in 1972
Collection of the American Museum of Natural History, New York
80.1/6902

51. Artist Unknown, Papua, New Guinea, Sepik River region
Middle Sepik
Mwai **Mask** (probably Iatmul)
wood, paint, shells
20 ½ x 4 x 3 ½
Collected by A.B. Lewis, 1909-1913
Joseph N. Field Expedition
Collection of the Field Museum of Natural History, Chicago
141306

The Middle Sepik River— Chambri Lakes

52. Artist Unknown, Papua, New Guinea,
Sepik River region
Middle Sepik, Chambri Lakes
Mask
wood
40 x 8 ½ x 4
Gift of Howard and Eunice Gelb
79.15.137

53. Artist Unknown, Papua, New Guinea,
Sepik River region
Middle Sepik, Chambri Lakes, probably
Aibom village
Interior Panel for Men's Ceremonial House
wood, shells, fiber, paint traces
77 ½ x 9 x 4
Gift of Howard and Eunice Gelb
79.15.100

54. Artist Unknown, Papua, New Guinea,
Sepik River region
Middle Sepik, Chambri Lakes, Aibom village
Storage Jar
red earthenware, paint
jar: 19" high, 19" diam.
base: 8 ½" high, 13 ½" diam.
Acquisition Fund Purchase
73.56.01

55. Artist Unknown, Papua, New Guinea,
Sepik River region
Middle Sepik, Chambri Lakes
Mask
wood, paint traces
34 x 7 x 4 ½
Gift of Howard and Eunice Gelb
79.15.08

56. Artist Unknown, Papua, New Guinea,
Sepik River region
Middle Sepik, Chambri Lakes
Mask. Modern design.
wood, paint traces
34 x 7 x 4 ½
Collection of Dr. Rhoda Metraux

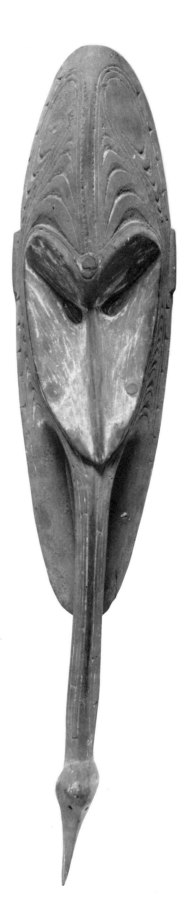

55. **Mask** / Middle Sepik, Chambri Lakes

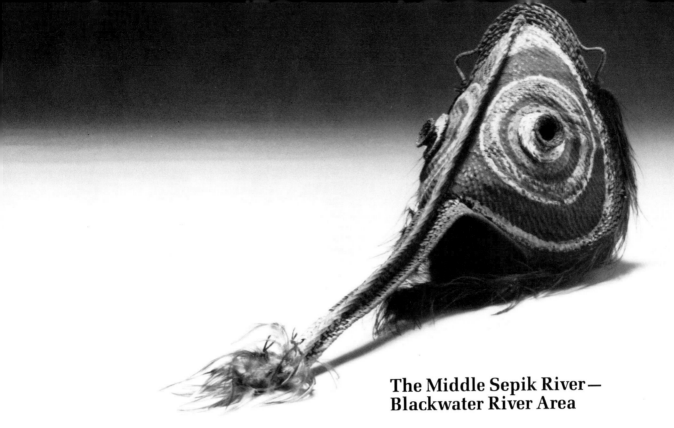

61. Mask / Middle Sepik, Blackwater River

The Middle Sepik River—
Maprik Region

57. Artist Unknown, New Guinea, Sepik
River region
Middle Sepik, Maprik region, Wosera people -
Manning village
Face Mask*(baba)*
rattan, paint
17 ¾ x 14 ½ x 5 ½
Acquisition Fund Purchase
73.56.03

58. Artist Unknown, New Guinea, Sepik
River region
Middle Sepik, Maprik region, Wosera people
Yam Mask
rattan, paint
19 x 8 x 2 ½
Gift of Howard and Eunice Gelb
79.15.169

The Middle Sepik River—
Blackwater River Area

59. Artist Unknown, Papua, New Guinea,
Sepik River region
Middle Sepik, Blackwater River
Kaninggara people - Kuvenmas village
Gable Mask
rattan, paint, fiber
68 x 59 x 14
Gift of Howard and Eunice Gelb
79.15.122

60. Artist Unknown, Papua, New Guinea,
Sepik River region
Middle Sepik, Blackwater River
Kaninggara people - Kuvenmas village
Mask
turtle shell, clay, rattan, paint, fiber
16 ¾ x 10 x 9
Gift of Howard and Eunice Gelb
79.15.74

61. Artist Unknown, Papua, New Guinea,
Sepik River region
Middle Sepik, Blackwater River
Mask
rattan, paint, cassowary feathers, fiber
14 x 30 x 11
Gift of Howard and Eunice Gelb
79.15.209

62. Artist Unknown, Papua, New Guinea,
Sepik River region
Middle Sepik, Blackwater River
Kaninggara people - Kuvenmas village
Male Suspension Hook
wood, paint traces, fiber, cowrie shells, tambu
shells
42 ½ x 9 x 4
Gift of Howard and Eunice Gelb
79.15.18

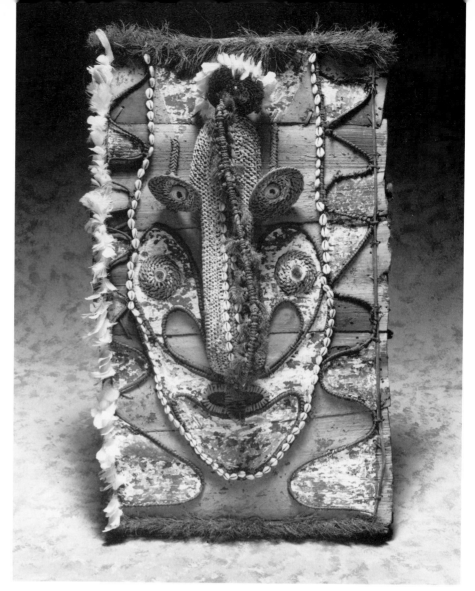

64. Gable Mask / Middle Sepik, Sawos people

The Middle Sepik River— Sawos People

63. Artist Unknown, Papua, New Guinea, Sepik River region
Middle Sepik, Sawos people
Suspension Hook
wood, paint, clay, shells, human hair, fiber
28 ½ x 11 x 9
Gift of Howard and Eunice Gelb
79.15.75

64. Artist Unknown, Papua, New Guinea, Sepik River region
Middle Sepik, Sawos people
Gable Mask
wood, rattan, paint, shells, feathers, fiber
42 x 26 ½ x 7
Gift of Howard and Eunice Gelb
79.15.164

63. Suspension Hook / Middle Sepik, Sawos people

The Middle Sepik River— Karawari River

65. Artist Unknown, Papua, New Guinea, Sepik River region
Middle Sepik, Karawari River
Hook Figure. Modern version of an earlier style.
wood
54 x 25 ½ x 8
Gift of Howard and Eunice Gelb
79.15.73

66. Artist Unknown, Papua, New Guinea, Sepik River region
Middle Sepik, Karawari River, Arambak people
Hunting Charm *(yipwon).* Modern version of an earlier style.
wood
39 x 15 ¾ x 1
Gift of Howard and Eunice Gelb
79.15.101

67. Artist Unknown, Papua, New Guinea, Sepik River region
Middle Sepik, Karawari River, Ewa people
Hook Figure *(aripa)*
wood, paint traces
41 ½ x 3 ⅜ x 7
Maurice Bonnefoy Collection, New York

68. Artist Unknown, Papua, New Guinea, Sepik River region
Middle Sepik, Upper Karawari River
Hunting Charm *(yipwon)*
wood
12 ½ x 4 ½ x 1
Gift of Mrs. C. A. Kleinoscheg, 1936
Collection of The National Museum of Natural History, Department of Anthropology, Smithsonian Institution, Washington, D.C., 377.599

65. Hook Figure. Modern version of an earlier style. / Middle Sepik, Karawari River

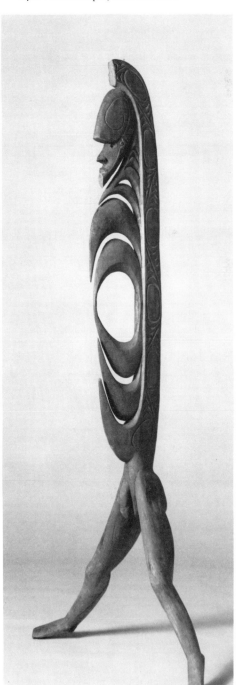

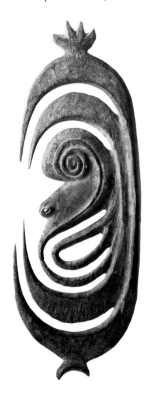

68. Hunting Charm *(yipwon)* / Middle Sepik, Upper Karawari River

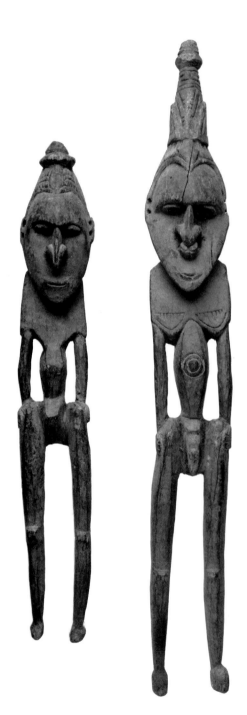

The Lower Sepik River

69. Artist Unknown, Papua, New Guinea,
Sepik River region
Lower Sepik, Angoram people
Helmet Mask
turtle shell, overmodeled with clay, rattan,
paint, fiber, human hair, feathers, shell, bone
14 ½ x 21 x 9
Gift of Howard and Eunice Gelb
79.15.147

70. Artist Unknown, New Guinea, Sepik
River region
Lower Sepik, Yuat River, Biwat people
Shield
wood, paint, raffia, cassowary feathers
68 x 12 ½ x 6
Gift of Howard and Eunice Gelb
79.15.l58

71. Artist Unknown, Papua, New Guinea,
Sepik River region
Lower Sepik, Angoram people
Mask
turtle shell, overmodeled with clay, paint,
cowrie shells, tambu shells, fiber, human hair
13 x 11 ¼ x 3 ½
Gift of Howard and Eunice Gelb
79.15.160

72. Artist Unknown, Papua, New Guinea,
Sepik River region
Lower Sepik, Angoram people
Cassowary Bone Dagger
bone, clay, shells, human hair
15 x 3 ¼ x 3 ½
Gift of Howard and Eunice Gelb
79.15.219

73. Artist Unknown, Papua, New Guinea,
Sepik River region
Lower Sepik, Angoram people
Neck or Chest Ornament
turtle shell, clay, paint, shells, human hair,
fiber
16 ½ x 6 ½ x 1 ½
Gift of Howard and Eunice Gelb
79.15.229

74. Ancestor Figures / Lower Sepik, Lower Ramu River

74. Artist Unknown, Papua, New Guinea, Sepik River region
Lower Sepik, Lower Ramu River
Ancestor Figures, 19th century
wood
Female: 20 ½ x 3 ⅜ x 2 ¾
Male: 27 ¼ x 3 ½ x 3 ¼
Collection of The Minneapolis Institute of Arts
75.31.1 - .2

75. Artist Unknown, Papua, New Guinea, Sepik River region
East Sepik Province, Bure, near Kayan
Mask
wood with paint traces
9 ¼ x 6 ½ x 4 ½
Collected by A. B. Lewis, 1909-1913
Joseph N. Field Expedition
Collection of the Field Museum of Natural History, Chicago
140370

76. Unknown Artist, Papua, New Guinea, Sepik River region
Lower Sepik
Adze
wood
29 long, 2 diam.
Collection of The Science Museum of Minnesota
72.22.4

The Sepik River Coastal Region

77. Unknown Artist, Papua, New Guinea, Sepik River region
Coastal region, Murik Lakes
Canoe Prow
wood
23 x 11 x 8
Gift of Howard and Eunice Gelb
79.15.111

78. Artist Unknown, Papua, New Guinea, Sepik River region
Coastal region, Ramu River
Mask
wood, paint, fiber
25 x 23 x 6 ¾
Acquisition Fund Purchase
73.56.02

79. Artist Unknown, Papua, New Guinea, Sepik River region
Coastal region, Schouten Islands - Wokeo
Mask
wood, paint traces
16 x 7 x 4
Acquisition Fund Purchase
73.56.04

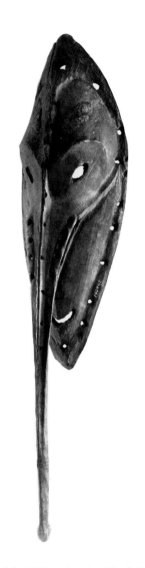

81. **Mask** / Coastal region, Murik Lakes

80. Artist Unknown, Papua, New Guinea, Sepik River region
Coastal region, Guam River
Cult Figure
wood, paint
49 ¾ x 4 ¾ x 3
Gift of Howard and Eunice Gelb
79.15.163

81. Artist Unknown, Papua, New Guinea, Sepik River region
Coastal region, Murik Lakes
Mask
wood
35 x 8 ½ x 5 ½
Collected by A. B. Lewis, 1909-1913
Joseph N. Field Expedition
Collection of the Field Museum of Natural History, Chicago
140947

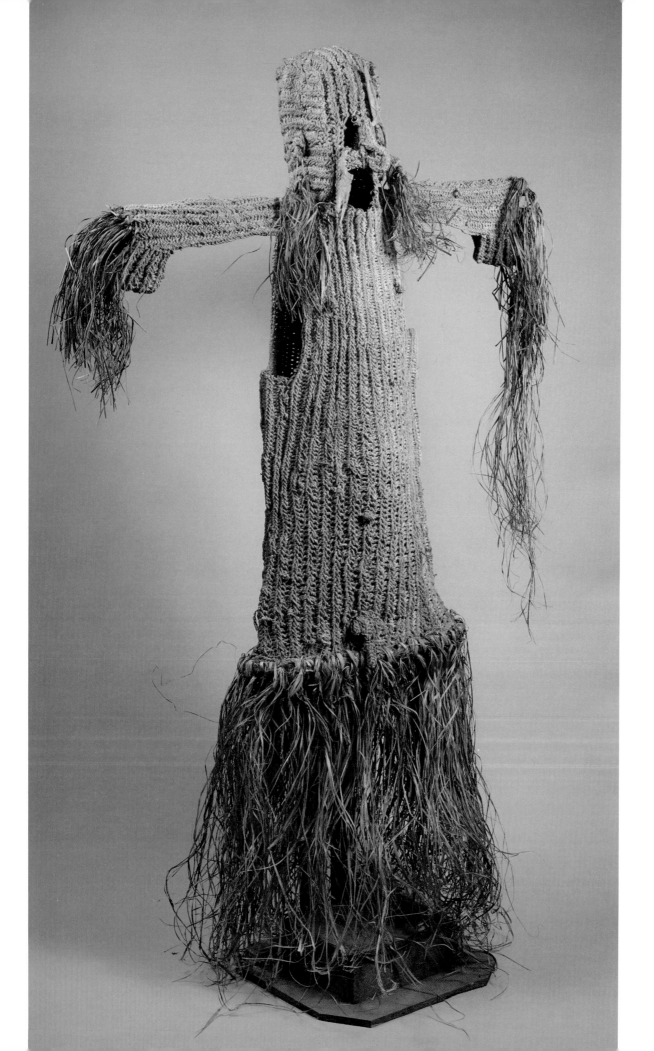

Change in Asmat Art

The Asmat live in the swamps of southwest New Guinea. Sixty to seventy thousand of them are spread over a vast area of ten thousand square miles on the Indonesian half of the island. Hamlets, compounds and villages range in population from thirty people to two thousand people. There are no roads; instead, myriads of interconnecting streams and huge rivers originating in the Jayawijaya mountains have become their lanes and highways. Canoes are essential to the way of life, for the people are hunters and gatherers and must enter the spirit-filled tidal forest along narrow waterways that lead to individually owned stands of sago palm. This tree, whose pith is pounded, rinsed and squeezed out to produce a pure carbohydrate, represents more than ninety percent of the local diet. The jungle, the rivers and the sea, along which many people live, are the sources of all food—sago, wild fruits and root vegetables, crabs, crawfish, shrimp, sea crocodiles and crocodiles of the rivers, sharks, dolphins, snakes, tortoises, land and water lizards, catfish, marsupials, wild pigs, wild chickens, hornbills, cassowaries and many other animals and insects. There is more than enough food; the Asmat have only to enter the forest and take it.

Formerly head-hunters and cannibals, the Asmat had an exceptionally rich culture in which elaborate carvings were made for rituals and feasts that took place cyclically and in almost continuous succession. These feasts were held primarily to placate ancestral spirits, whose deaths had to be avenged. Death, they still believe today, occurs only through magic or direct violence in individual fights or warfare, except for the deaths of the very young and the very old. Spirits of the dead demand vengeance, for it is only through the death of an enemy that the spirit of the dead person can be appeased and will then leave the land of the living for *safan*, land of the dead. That life can be renewed or created only through death is an idea basic to Melanesian thought.

Carvings are named for the dead and are meant to remind the living of their obligation to avenge their deaths. They are the embodiment of the dead person. A war shield named for a recently killed father or uncle will give that man's strength to the shield's owner and will give him a power he would not otherwise have. Almost everything the Asmat make—spears, canoes, paddles, drums, food bowls, even fireplaces in men's houses—are named for specific persons whose spirits will remain in the village until vengeance has taken place.

Many carvings are made for certain rituals, without which the ritual cannot take place. The great ancestor poles *(mbis)* for which Asmat is famous, are made for head-hunting and initiation ceremonies only among the Bisman people of the coastal region. In other areas, completely different carvings are made; in the northwest, there is the *wuramon* or soul ship, and in the central area of the Eilanden River, there appears the *basu suangkus*, a group of carvings whose name translates into "the making visible of the heads of men who have been killed in battle."

107. **Spirit Mask** *(jipae)* / Asmat people - Fayit River

The Asmat do not think of their carvings as works of art, nor of their carvers as artists. A man who carves is simply described as *tsjestsju ipitsj*, clever man, or *wow ipitsj*, design man. It is this clever man or design man who, once an object has been requested, makes all the decisions concerning the tree to be cut down, the rituals to be performed, when the rituals are to take place, the designs and tools to be used and, at the completion of the work, the paint and final decoration that go with it. All this is based on tradition. The owner of a ritual object such as a shield might with the passing years become so identified with the shield that he will believe himself to have been the original carver. Such feelings of transference and emotional attachment have unfortunately long since begun to disappear. It is rare, except in the remote areas, for young men to understand the relationship between a carving, the spirit world and the carver himself. These young men may continue to believe in the spirit world but they no longer relate to the sanctity of the carved wood and see it instead only as a source of financial gain. Tools have always played an essential role among artists and craftsmen and usually become an extension of their minds and bodies. These too have lost that vital spirit through which the carver communicates with his wood.

The art of Asmat has, in many cases, remained faithful to the spirit of the past, changing only within the limits of its own culture. In other cases, however, the work has been altered under the influence of outsiders. This is not to challenge ideas that come from foreign cultures as not being fruitful. As far as its art is concerned, however, this foreign influence in Asmat has been a negative one. Even though Asmat has gained with that contact to the extent that carvings have become objects for sale, the artistic quality of certain types of carvings has deteriorated with the introduction of new concepts and tools.

Changes in thought and materials brought primarily through Dutch missionaries in the late 1950s have given a different character to the art of

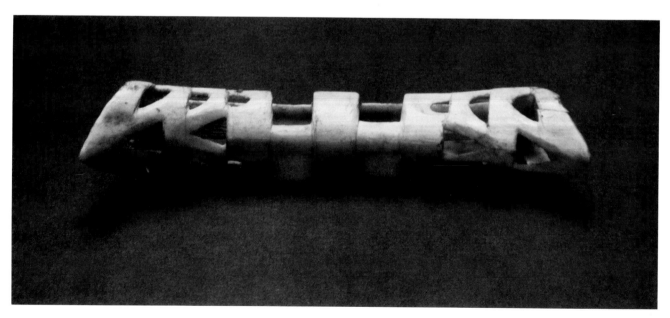

129. Nose Piece / Asmat people

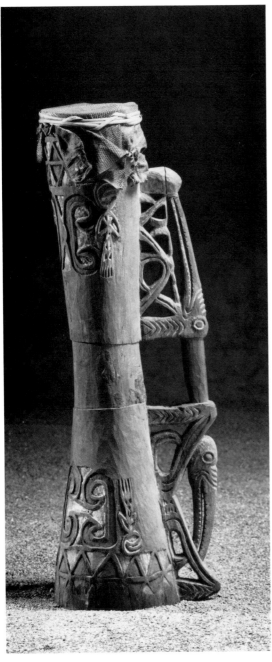

128. Drum *(em)* / Asmat people

Asmat. Their influence has been striking, although the introduction of metal tools cannot be associated with any individual or group. Metal, in fact, first appeared in Asmat as nails in planks of wood that floated up the Eilanden River with the tide. These planks came from ships that had run aground in the shallow Arafura Sea and had later broken apart. The Asmat recognized the value of these nails and pounded them into chisels with stone on stone. This nail chisel became the basic tool for carvers in Asmat. Stone axes and stone adzes, cassowary bone chisels, mussel shell scrapers and the teeth of various small animals were the original tools with which they carved their extraordinary works. The first documented carving to appear in the West, however, was a war shield in the Rijksmuseum voor Völkenkunde, Leiden, dated 1906, and made with metal tools. It came from the Casuarina Coast of south Asmat. Shields taken out of the northwest in the 1920s and even later were still being carved with stone and bone tools. Further upstream, in the foothills of the snow-covered mountains, the most remote area of Asmat, these tools were still in use at least as late as 1983.

There is a vast difference between carvings made with metal and those made with stone and bone and shell. The power and striking imagery of shields carved in the old manner are missing in the newer, more refined work, although much of the loss of power in many regions has to do with the loss of interest in ritual carving itself. This lack of interest was not helped by the ban on rituals and carvings from time to time by individuals in the Indonesian government. Today, carvings are most often made for sale. Rituals sometimes take place with the idea in mind of selling the carvings after the feast is over. The reverse of this is also true; ritual carvings made for sale still have such an extraordinary effect on the people that the rituals must be performed and the carvings named before they can leave the village. Carvings made in this way are invariably as good as any works of the past.

Tradition dictates the form of a carving but does not insist on duplication. On the contrary, within its limitations, there is great scope for the carver to

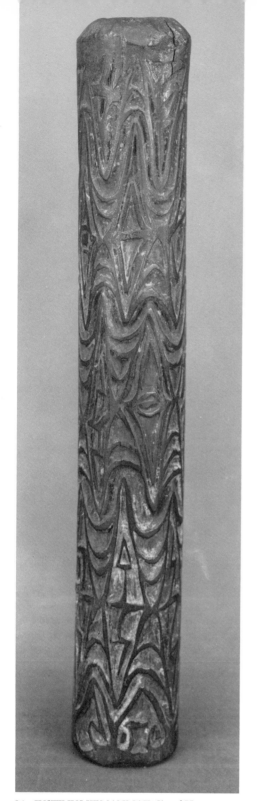

91. JUSTINUS KEMANMAK, Signal Horn
(fu) / Asmat people - Sawa village

display his creativity. The use of metal tools not only meant change but even encouraged particular types of carvings. Metal led to technical refinements such as the *ajour* carvings of the villages of Atsj and Amanamkai and the plaque reliefs of the Sawa-Erma area. Such delicate and fastidious workmanship could not easily have been achieved with the old tools. Although the nail chisel is the primary tool, the roughing out of the log itself is done with a steel axe or *parang*. The smooth, sleek surface of the *ajour* and certain other works can only be obtained with the mussel shell scraper. It is precisely the right size, shape and sharpness for easy handling.

In shields made without the use of metal, the immense difference in texture is obvious. They are rougher and the design is not always centered or perfectly balanced. Nevertheless, there is a startling energy emanating from them, a strength and impregnability meant to terrify the enemy who sees them. The aesthetic difference is not visible to every eye; most Westerners and some Asmat prefer the regularity and slickness of the new *ajour* carvings.

The earliest figure carvings in the Leiden collection appear to have been carved with stone and bone tools. They, too, have an intensity and boldness not seen in later work. Some of this may have to do with the almost religious passion with which they were carved, particularly the ancestral figures made for ceremonial occasions. When the rituals were over, the carvings were taken to the stands of sago in the jungle, broken up to release the spirits therein and left there so that the spirits might protect and nourish the trees. The most meticulous work was reserved for the more permanent artifacts such as drums, food and paint bowls, and spears and paddles which, with time and use, developed a radiant patina and smoothness. Under Western influence most carvings suggested another presence; they are, however, always instantly recognizable as Asmat through their subject matter, shape and motif, except for those of purely Western symbolism.

Father R. von Peij, a Dutch missionary, first suggested the idea of *ajour* carvings in the village of Atsj in the late 1950s. The concept came to him from the prowheads of war canoes. He gave Nikolas Kow a wooden plank on which he himself had drawn several human figures in profile, seated in praying mantis position, with elbows on knees. He told Nikolas to cut out the spaces around the

lines, as if the plank were indeed a prowhead. Thus was born the first *ajour*, probably the most desirable and also the most fragile of Asmat tourist carvings today. They still have Asmat motifs—ancestral figures, star stone axes and hornbills— but they have lost all ritual meaning.

Von Peij is also partly responsible for a type of carving that lay within traditional lines but was at the same time, different from anything before it. He had asked Kokoputsj, the chief of the village of Per, to carve a crucifix. Kokopustj had already seen carvings and photographs of paintings and sculpture of Christ on the Cross. Von Peij explained the story of Christ, "who died for us and came back to earth to help all human beings." In the past, the Asmat often placed their dead in the roots of banyan trees, where certain spirits dwell. Banyan tree root designs are common in the south of Asmat and often appear at the lower end of ancestor poles. Kokoputsj had made a connection between those ghost-filled trees and Christ, who returned three days after his death. Until the deaths of ancestors in Asmat are properly avenged, their spirits return to the living to goad them on to vengeful acts. Kokoputsj's interpretation of the Resurrection, depicting the head of Christ within those roots, was, therefore, a logical one. The carvings were made of ironwood, about five feet high, and were wonderfully shaped, carved and polished. They were a little unusual for Asmat and looked as if they might have been conceived under the influence of Noguchi. At first Dutch missionaries and later on Americans began asking for crucifixes closer to the Western ideal of that image and the Asmat were quick to respond by producing them, as well as statues of the Madonna and Child, for sale. Although made in Asmat, they had no suggestion of Asmat about them.

Father van Dongen started another tradition when he gave ironwood boards to his carvers and asked them to incise designs similar to those on bamboo horns and shields. He later fitted these boards together with nails and hinges, to make chests and boxes that were shipped to Holland on the log-carrying M.S. Letong. Some years later, Jac Hoogerbrugge of the International Labor Organization tried to introduce a cash economy by continuing this tradition further upstream in the villages of Sawa and Erma. There carvers first cut their ironwood planks by hand in the shape of shields, scaled down for easy sale and transport.

New ideas can and do appear spontaneously within any culture. A carver might suddenly decide that the prowhead he is working on might be enhanced with the addition of a design not previously seen—a cassowary, a pig, or at least in one known case, an airplane. Size too can change through the use of metal tools. The earliest known example of an ancestor pole was collected on the Eilanden River in 1923 by Paul Wirz. It is a little over ten feet high and is in the Museum für Völkerkunde, Basel. Many ancestor poles collected on the Eilanden River thirty, forty and fifty years later were at least twice that height. Since the Eilanden already had metal tools at that time, it can only be surmised whether or not the tools had caused the change. It was the use of metal tools that made the plaques, crucifixes, and *ajour* carvings possible.

Almost everything in these categories has now become what can only be called "airport art." The plaques turned into machine-sawn boards. The banyan

root carvings of symbolic crucifixions turned into figures of Christ on the Cross that no longer had any liveliness or surface texture. The *ajour* were so refined and delicate that they became examples of how far the carver could go without having the carving break in his hands: the art had been refined out of existence. A carver, unless a true master, can only go so far with his technique; beyond that, his work becomes mechanical. The possibility of pushing the technique to its limits is inherent in the metal itself, even though the tool is formed by the Asmat. The bone and stone of former times would not permit this. Not all carvings in Asmat have been debased by the use of metal; superb ritual carving can still be

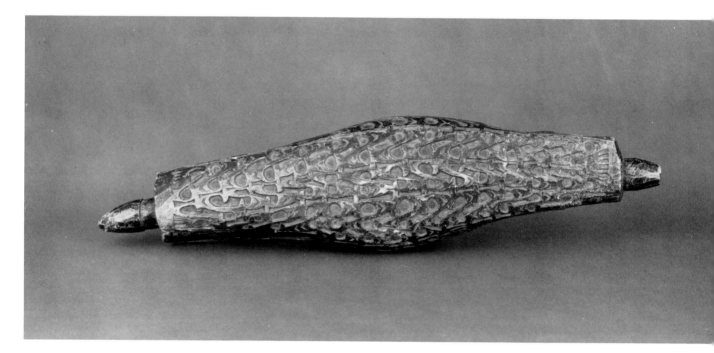

89. Neckrest *(wiwas)* / Asmat people - Casuarina Coast

found, though the rituals themselves are being debased through outside influence. There are, however, still carvers whose sense of tradition remains intact.

In Agats, capital of Asmat, a museum was built by American Crosier missionaries to house Asmat artifacts. The primary purpose of the museum was to keep the Asmat from losing their sense of identity and contact with their own history. The plan also called for it to be a center of education, with lectures, slide shows and films. It opened in 1973 and has not only encouraged carving by buying artifacts from all areas of Asmat and putting as many on display as possible, but has initiated a contest for carvers, with prizes awarded every year. Many carvers whose works are on display are able to see for the first time the importance their carvings have in the eyes of the world.

When David Simni, oldest war chief of the village of Sjuru, first entered the museum he was hesitant and wary of the spirits emanating from the carvings. He was awed as well by the building itself and by the variety and number of

artifacts. He wore a ragged shirt and ragged pair of shorts; his back was bent and he shuffled his bare feet on the polished ironwood floor. He exclaimed in surprise "Aduh!" when he saw the syrinx aruanus shells on display and went right up to them. He reached out and put a hand on the largest shell, the type he formerly had worn to exhibit his prowess as a head-hunter. He touched the shell tentatively, patted it, picked it up and put it against his navel, where it would have been tied with a string around his waist. "Aduh!" he said again. He held the shell there, then lifted it to his cheek and nuzzled it into his shoulder; he cradled it in the crook of his elbow and stroked it tenderly.

It was not difficult to imagine the memories that must have flooded through his mind—the scenes of great battles, the raids and fights, the killings and cannibalism, the ceremonies and rituals that had obsessed him and all Asmat until only a few years earlier. He moved around the room, speaking in a tone so low that his voice was almost inaudible, although his feelings were unmistakable. He touched the spears lightly with his fingertips, outlined the designs on shields and ran his hand over the figures on the ancestor poles. He recognized instantly all objects that had been part of his former life, the life that had gone with the coming of the missionaries and the Indonesian government. He passed by objects that were tourist or "airport art" as if they did not exist, but his unerring eye stopped to examine carefully those pieces that had been ritualistic. These included objects that he had never seen before, which had come from other parts of Asmat. He instinctively understood their meaning and power.

Simni longed for the past but he, like most Asmat, preferred the less violent life of the present and the freedom to wander in the forest for food without being constantly on the alert for enemies. Some old-style ceremonies are being performed again and old-style carvings are appearing in the villages in which men and women have begun to comprehend the value of the past and are taking it with them into their future.

Tobias Schneebaum
Professor
New School for Social Research, New York, and Lecturer on Asmat Art and Culture, American Museum of Natural History, New York

Catalog Entries for Selected Objects

Ajour Carvings

Ajour carvings are elegant openwork ancestor carvings now made by the Asmat specifically for sale to tourists. The word *ajour* derives from the French word meaning "pierced," which appropriately describes these intricate and delicately refined images. They are carved in profile out of a flat ironwood board with the new metal tools used by the Asmat. The sensitive, detailed carving is still done with nails pounded into chisels, but the works are blocked out by steel axes, adzes and Indonesian *parangs* (knives). The ancestors pictured in these carvings are often joined together by decorative motifs used in the old head-hunting culture — the hornbill, the flying fox, the praying mantis and the fearsome, red-eyed black king cockatoo.

Ajour carvings were first made in the 1950s in the village of Atsj. A missionary, Father R. von Peij, derived the design of these carvings from the traditional Asmat prow head. Nicholas Kow, the first carver of *ajours*, was given a flat wooden plank upon which were sketched profile drawings of human figures seated in the praying mantis position. Father von Peij then asked Nicholas to carve out the spaces between the lines, which resulted in the first ajour.[1]

Modern *ajour* works have become so refined that they must be handled with great care in order to prevent breakage. They have also become "assembly-line art" and are purchased in great quantities by tourists. The Western eye is intrigued by their repetitive patterns and as tourists buy, they unwittingly perpetuate the creation of inferior works.

The original prowheads, from which modern *ajours* derived, seethed with energy and vitality. The old tools used in their making imparted a surface roughness that the people liked. The Asmat, however, have now become used to the smooth surfaces and the graceful, simple rhythms and many now prefer the new to the old.

L.A.K.

[1]Tobias Schneebaum, "Some Thoughts on Tools and Changing Carvings in Asmat" (*Pacific Arts Newsletter* l: January 1983): 7 - 14.

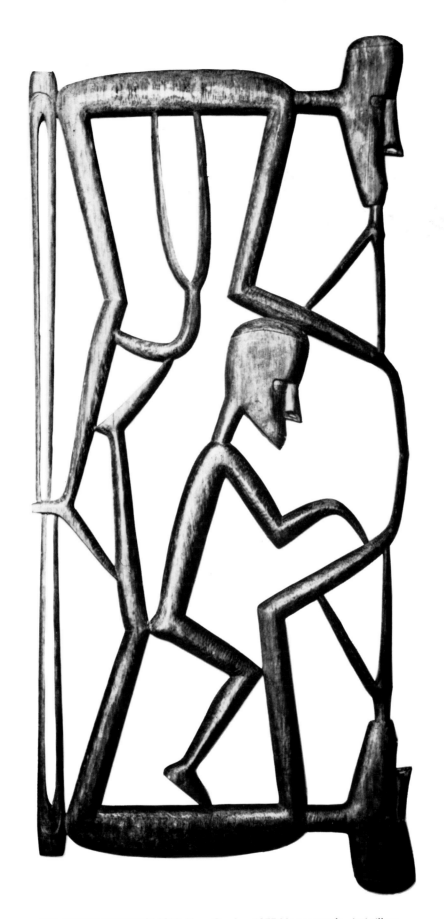

110. **SOTER PATARKOMON,** Ajour Carving, 1977 / Asmat people - Atsj village

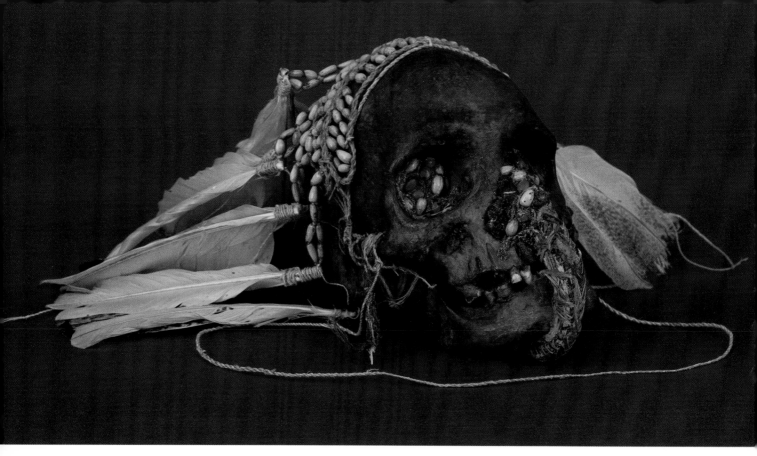

Ancestor Skulls

Ancestor skulls served two purposes in the Asmat head-hunting culture. They acted as constant reminders to the people that slain ancestors were to be avenged and provided an avenue of communication between the dead and the living. Ancestral spirits were thought to be restless, and as potentially dangerous to the Asmat as spirits of enemies.

Ancestral skulls were either worn tied around the necks of the men as body ornaments, or used by them as headrests. They protected the wearer from malevolent spirits and provided guidance on a daily basis. The Asmat believed that the spirit and the body were joined in life, but that the spirit was restless and could depart the living body at any time, particularly when a person slept. Resting one's head upon a skull to control the unruly spirit was thought to be efficacious.

Although not painted, as were the ancestral skulls of the Sepik River peoples, Asmat ancestral skulls were lavishly decorated. The eyes and nose holes were first filled with beeswax and then inset with colorful shells and seeds—silvery coix shells and red abrus seeds were a favorite combination. The forehead was traditionally adorned with a band of coix seeds and white cockatoo feathers. The jawbone was attached to the skull with braided rattan, which passes through the nose, under the chin and in at the side joints.

L.A.K.

Figure Carvings

The Asmat believe that the spirits of the dead roam about freely and must be provided with a dwelling place before they may be approached by the living. Ancestor figures are carved which personify dead family members and carry their names. The people regard them as living beings; they honor them and ask them for guidance and protection during periodic festivals. They are always carved from one piece of wood and are stored in the men's house (*yeu*).

Festivals occur when the village chiefs and elders decide that the influence of the village ancestors is too strong and the restless spirits must be dispatched to the world of the ancestors (*safan*). Distinctive ancestral figures, ancestral poles (*mbis*) and soulships (*wuramon*) are carved for these ceremonies. The spirits residing in these carvings are first placated by an act of revenge for their deaths. In the traditional culture, the taking of heads fulfilled this need. The people then convince the ancestors of their communal strength and encourage them to leave the area. The ancestral spirits are then free to travel to the spirit world and remain there forever.

Asmat figure carvings were made when a new men's house (*yeu*) was built. They were stored in the men's house when not in use and the uninitiated boys and village women were forbidden to look at them. Single figure carvings were also made for the feast which commemorates the creation of mankind by the great ancestral wood carver Fumeripits.

L.A.K.

97. Ancestor Figures *(kawe)* / Asmat people - South Casuarina Coast

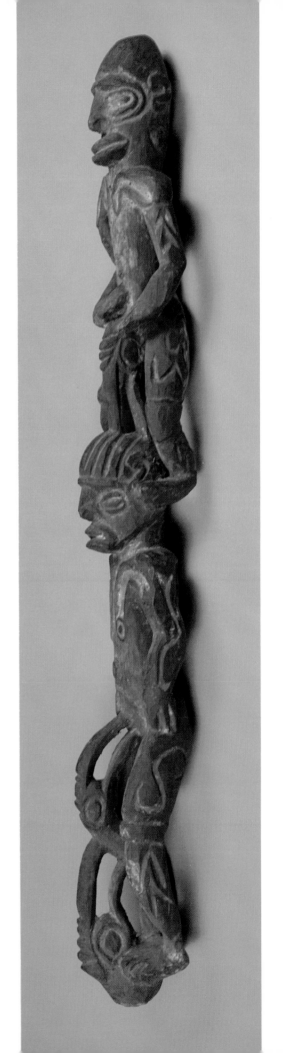

Soul Ships

Carved out of a single piece of wood, Asmat soul ships are monumental and shaped like dugout canoes. These ships were carved over a long period of time and were used ceremonially by the people in two festivals. One festival was held to expel the souls of people who had recently died and were still roaming about the village. During this ritual, the soul ship was set up in front of the men's house *(yeu)*. It was then attacked in a mock battle involving the men living in the upstream half of the house and those living in the downstream half. As a result of this internal skirmishing, souls of the dead departed the village and the ship was left to decay in the sago palm grounds.

The ships were also carved for the initiation rites of young men. Initiates were confined for months in specially built houses. They were not fed and were not allowed fires and could leave the house only under cover of darkness. When all ritual acts had been performed, the soul ship was carried by the men to the initiates' house and moved partially through the doorway. The men then groaned and moved the ship rapidly in a back and forth motion; the

102. **AMANDOS AMONOS, Soul Ship *(wuramon)*** / Asmat people - Jamasj village

groans imitated a woman's giving birth and symbolized the new birth of the initiates as adults. The soul ship was then placed in front of the house and the new adults crawled out of their prison over the ship. They were also required to sit on the carved turtle in the center of the *wuramon,* while the elders carved scarification marks onto their legs with an animal tooth.

The traditional carvings which ride in the *wuramon* represent both ancestor figures and environmental spirits. Human-like creatures (*etsjo*) and spirit figures with bird-like heads (*ambirak*) line up in mythically sanctioned order. They are all carved in slouching positions, and all face downward.

The botton of the canoe is open, presumably so that the human-like figures representing ancestors will be able to escape into the waters of *safan,* the land of the dead. The *ambirak* and the *okom* (a curiously shaped Z-like figure) are water spirits. The turtle figure (*mbu*) in the center of the ship symbolizes fertility. All figures in the ship must be named and sit in a particular order, so they can travel peaceably together into the spirit world.

L.A.K.

Canoe Prows

Asmat dugout canoes, particularly the huge war canoes, were often embellished with artistically carved prowheads. Prows were not necessarily carved along with the canoe from one piece of wood; they were often carved separately and then attached to the canoe on the occasion of a canoe feast. They were carved either by the canoe's owner, if the prow was to be used for domestic travel, or by the village's master carvers, if it was a ceremonial work destined for the great war canoes.

The figures on the prow represent ancestors whose deaths must be avenged by relatives. On one of the three prows in the exhibition, ancestors are portrayed with brutal realism. Two figures are depicted seated upright holding the decapitated head of the ancestor which requires vengeance. The prow itself is shaped like the canoes which glided silently out of the villages at dawn to raid neighboring villages. Its head is a stylized depiction of the black king cockatoo bird, an image closely related to head-hunting.

Prows were also regarded as the *tsjemen* (penis) of the canoe and symbolized male prowess. The intricate openwork designs found on most prowheads may represent the roots of the sacred banyan tree, where the bodies of the dead were left to decompose, or they may simply be abstract renderings of wading birds. Prows were painted in the Asmat color triad of red, black and white; white was the basic color and was used liberally on all carvings, red was used for scarification marks and outlining the bones and black represented body hair.

Memorial canoe prows received the name of the villager who had died in a ceremony held prior to a raid. At this ceremony, the brothers-in-law of the deceased were given a long stick filled with sago worms and large ball of sago. Sago was, and still remains the staple food of the Asmat. The food was taken by canoe to the place on the river where their relative had died. They placed the food on a small rack and offered it to the deceased. A few grubs were then dropped into the river, and the mat covering the new prow was removed, so all could see it. The rest of the food was then taken back to the village and roasted and eaten by the brothers-in-law.

L.A.K.

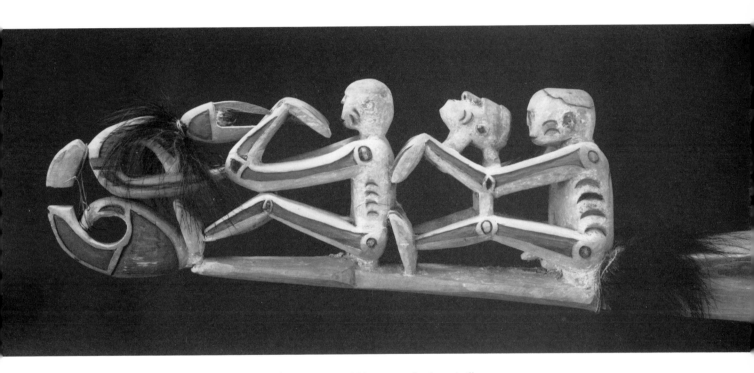

102. **AMANDOS AMONOS, Canoe Prow, Soul Ship** *(wuramon)* / Asmat people - Jamasj village

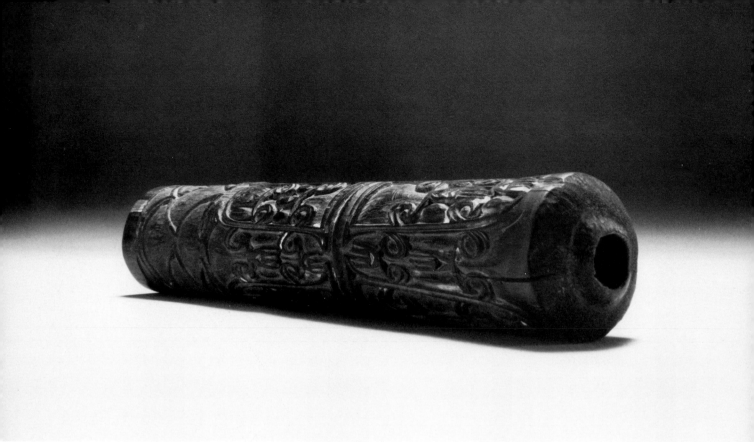

130. **Horn** *(fu)* / Asmat people

Horns

 Asmat horns imitate the sound of the dreaded crocodile and were used in the traditional culture to frighten the enemy village during head-hunting raids. They were also used to herald the return of the war party and announce their success. Each canoe had its own horn and the villagers could estimate the number of heads taken by listening to the different pitches of the horns. They were also used as signaling devices and were kept by each household door to warn people of impending danger.

 Horns are carved from a section of green bamboo. One partition that separates each section of bamboo at the joint is removed and the partition at the other end is fashioned into a mouthpiece. The surface of the horn is covered with abstract, incised patterns, which are interspersed with other traditional Asmat designs such as the flying fox and praying mantis.

L.A.K.

Ancestor Poles

The Asmat believed that death did not normally result from natural causes; a man either died in warfare or as a victim of black magic. If revenge was not taken by his family members, he could not travel to the spirit world of the ancestors. Ancestor poles carved by the coastal Asmat personified the spirits of the dead and served as reminders to the people that their deaths must be avenged.

Ancestor poles were carved at a pole feast initiated by the men of a village to avenge all of the recently dead. In the traditional culture, pole feasts, initiation ceremonies and head-hunting raids occurred simultaneously. During the feast, the freshly carved poles were named for the deceased and set up in front of the men's house (*yeu*). Dancing and drumming then took place, which culminated in a mock battle staged by the men. The women then danced and attacked the men, symbolically expelling the restless spirits of the dead from the village. The taking of heads from an enemy village was the ultimate act of revenge and climaxed all the preceding ceremonial events.

Two types of poles were traditionally carved. Towering poles cut from mangrove trees with intricately carved wings projecting from the top were made specifically for the pole feasts. The wing represents the penis (*tsjemen*) and symbolizes male power. The figures on these poles were placed in order of rank and family. After the feast, the poles were carried to the sago palm grounds and left there to decay and promote fertility. Smaller poles were also carved from ironwood, which were stored in the men's house by each man's individual fireplace. These figures served as advisors and gave protection to their relatives.

L.A.K.

101. Ancestor Pole *(mbis)* / Asmat people - Buepis village

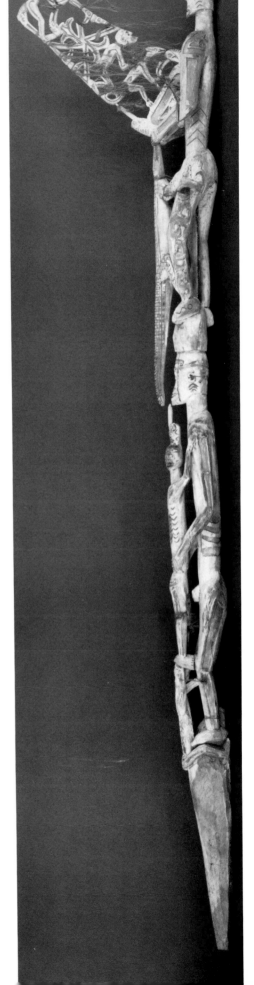

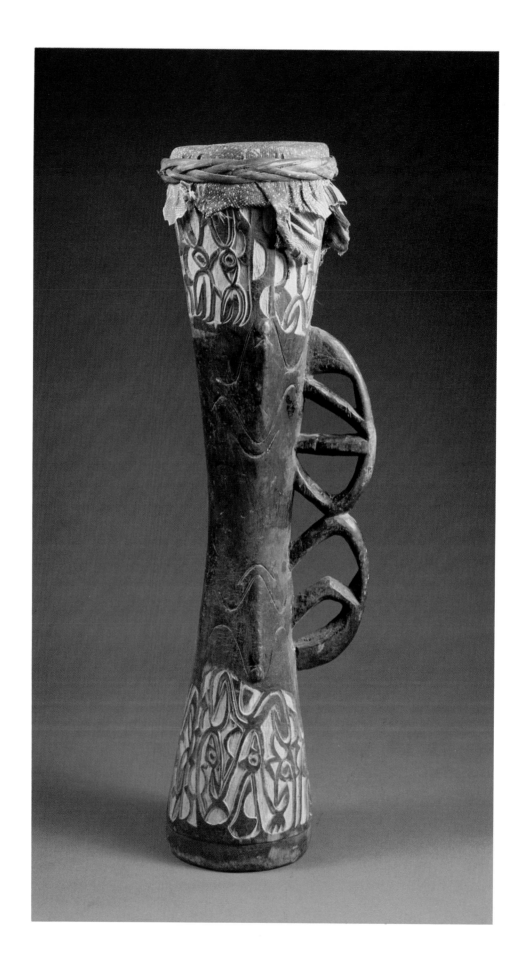

Drums

In Asmat myth, the drum is the instrument of man's creation. The creator, Fumeripits, was seated alone in his jungle house. He was lonely, because there were no people with him to share his life. He decided to make some carvings, each with a head and a body and two arms and two legs. Some he made male, some female. He placed the carvings in his house and admired them, but he was still lonely. He then began to carve a drum. He felled a tree and hollowed it out. Putting a lizard skin over one end, he attached it to the drum with a mixture of lime and his own blood. He then tied a rattan band around the drum head. When the drum was ready, he began to beat on it. The carvings he had made began to move in a dance. The carvings became human beings, and in this way the first Asmat appeared.

Drums are the Asmat people's major musical instrument. They are still made in the same manner described in the creation myth recounted above. Drum carving is a lengthy and meticulous process. The core of the log is first beaten out with a strong palmwood stick and then the interior is shaped and enlarged by burning. Both body and handle of the drum are often intricately decorated with carvings of head hunting symbols such as the black king cockatoo, hornbill and praying mantis. Drums are named for someone who has recently died, and are held by the handle and rest between the arms and thighs when played. Asmat drum music is simple and accompanies ritual songs and dances at festivals. Drums are tuned by warming the lizard skin tympanum over a fire and attaching tuning knobs made of beeswax to the skin. Due to the extreme humidity of the Asmat climate, they must be retuned every twenty to thirty minutes during actual use. They are played by hitting the drumhead with the fingers of one hand, and the pitch of the single tone that is produced is regulated by the length and diameter of the drum.

L.A.K.

84. Drum *(em)* / Asmat people - Momogo village

Shields

Asmat shields are cut from the large plankroots of the mangrove tree and then painted in the traditional Asmat colors— red, white and black. Shields were carried in head-hunting raids for physical protection against arrows and spears. Their true benefit, however, was the power derived from the ancestor for whom the shield was named. They were carved at a shield feast initiated by the war chief or village elders and named after a deceased relative of the owner. When carried into an enemy village at dawn on a head-hunting raid, the shield's threatening presence both intimidated the enemy and spurred the owner on to victory.

The shields and the intricate designs carved on them symbolize the ancestors, whose deaths must be avenged before they can pass on to the spirit world (*safan*). At the death of the owner, the shield was either broken into pieces and used to cover the body or was given to the owner's son. Design motifs carved on the surface of the shields depict both powerful ancestral figures and head-hunting symbols. Fruit-eating birds and animals such as the hornbill, the black king cockatoo and the possum (*cuscus*) are considered magical motifs that symbolize the taking of heads. To the Asmat, a man was identical with a tree and his head was the tree's fruit. Thus, fruit-eating birds and animals were thought to be efficacious for the taking of heads and were abstractly pictured on the shields. The voracious female praying mantis, who bites off the head of the male after mating, was another ubiquitous shield motif.

L.A.K.

123. War Shield *(jamasj)* / Asmat people - Pirimapun village

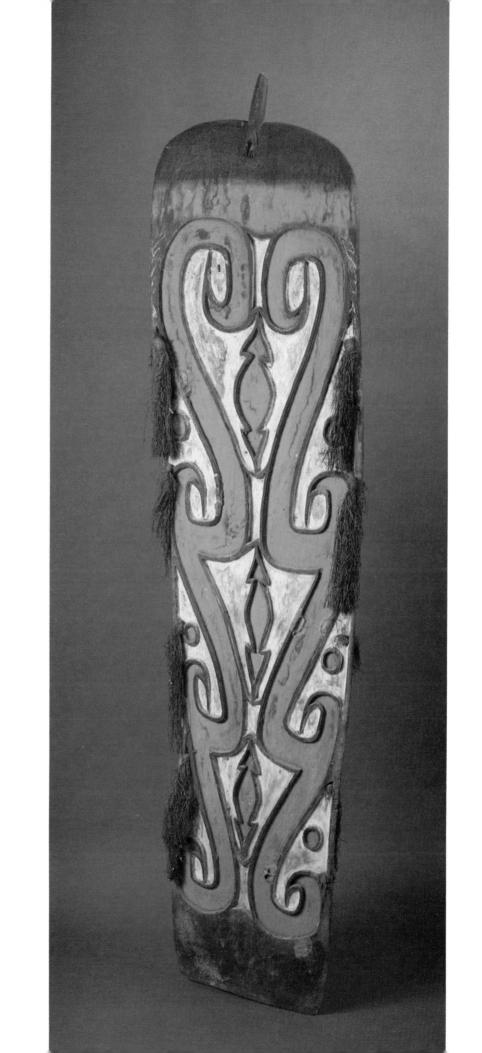

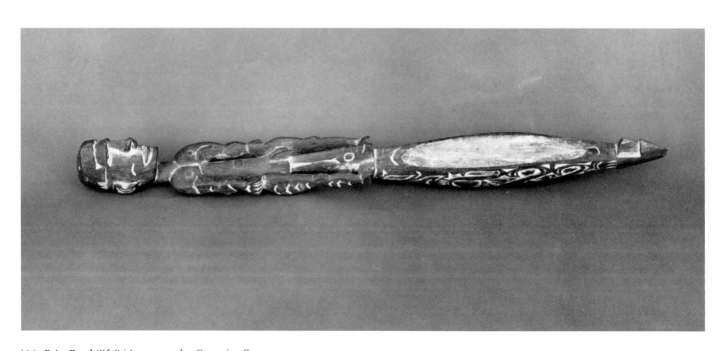

116. Paint Bowl *(jifai)* / Asmat people - Casuarina Coast

72

Bowls

The Asmat people carve bowls for both utilitarian and ritual purposes. They are made only in central, coastal and northwest Asmat, and are used both as food containers and for mixing paint. All bowls are named for specific ancestors of the owner, and ancestral faces and figures are often carved at each end of the bowls. In traditional bowls these motifs always faced upward so they could be addressed by the user. When stored, they were placed upside down on wooden racks directly above the owner's fireplace so they could bestow favors from above.

Bowls from the traditional culture were probably all canoe shaped, while modern ones tend to be more rounded and flattened and have the ancestor figures at the ends facing down rather than up. The canoe shaped bowls were used primarily for mixing red paint for the red, white and black Asmat color triad. The red paint symbolized blood shed by an enemy lying in a war canoe. These dead bodies assured the continuance of life to the people of the head-hunting culture. Many of the canoe shaped bowls were also used for holding food and these often had two ancestral figures, one male and one female, cradling the bowl between their legs. These bowls also symbolized fertility and life's sustenance.

In outlying areas of the Asmat, bowls were made of sago spathe which was sewn together to form a container. These bowls were used throughout the Asmat as ritual containers for the sago worms that were served at the great festivals. In the head-hunting culture, they were also used to hold human brains which were scooped out of the skull of the dead enemy and fed to the elders of the triumphant village.

L.A.K.

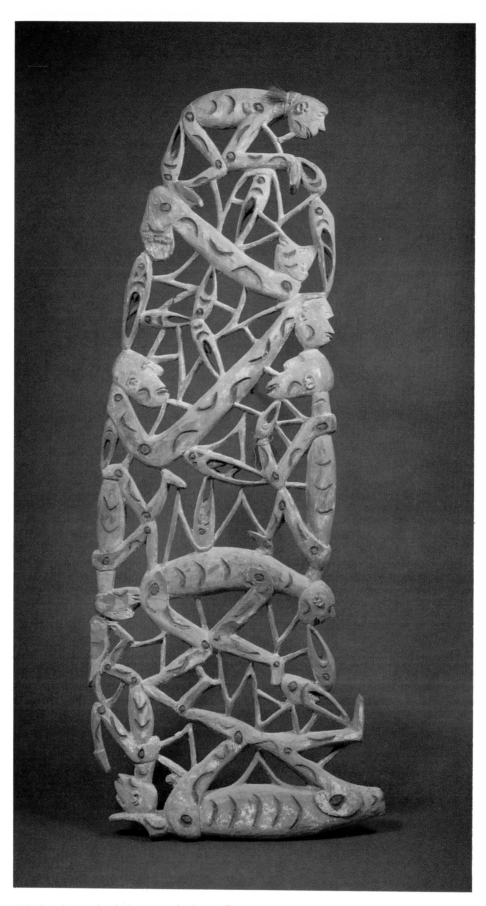

112. Pseudo-prowhead / Asmat people - Sawa village

Checklist

The Asmat

82. Artist Unknown, New Guinea, Irian Jaya
Asmat people - Per village
Drum *(em)*
wood, rattan
22 ¾ x 7 x 6 ¾
Collection of the Crosier Asmat Museum
0708

83. Artist Unknown, New Guinea, Irian Jaya
Asmat people - Northwest Asmat region
Drum *(em)*
wood, lizard skin
31 x 7 ½ x 7 ¼
Collection of the Crosier Asmat Museum
0057

84. Artist Unknown, New Guinea, Irian Jaya
Asmat people - Momogo village
Drum *(em)*
wood, lizard skin, rattan
25 x 6 x 6
Collection of the Crosier Asmat Museum
0414

85. TAMSE, New Guinea, Irian Jaya
Asmat people - Pupis village
Sago Bowl *(jifai)*
wood
3 ¼ x 23 ¾ x 10 ¼
Collection of the Crosier Asmat Museum
0315

86. Artist Unknown, New Guinea, Irian Jaya
Asmat people
Crucifix
wood
13 ½ x 8 x 2 ¼
Collection of the Crosier Asmat Museum
0184

87. DJOSE, New Guinea, Irian Jaya
Asmat people - Mbu Agani village
Sago Bowl *(jifai)*
wood
2 ¾ x 26 ¾ x 8 ¼
Collection of the Crosier Asmat Museum
0320

88. Artist Unknown, New Guinea, Irian Jaya
Asmat people - Kombai village?
Adze *(tsji fom)*
wood
20 ¾ x 19 ¼ x 2 ½
Collection of the Crosier Asmat Museum
0304

89. Artist Unknown, New Guinea, Irian Jaya
Asmat people - Casuarina Coast
Neckrest *(wiwas)*
wood
6 ½ x 28 ½ x 3 ¾
Collection of the Crosier Asmat Museum
0212

90. AIREM, New Guinea, Irian Jaya
Asmat people - Vakam village
Smoking Pipe and Extension *(bus)*
bamboo, reed
Pipe: 16 ¼ x 1 ½ x 1 ½
Extension: 14 ½ x ½ x ½
Collection of the Crosier Asmat Museum
0342

91. JUSTINUS KEMANMAK, New Guinea,
Irian Jaya
Asmat people - Sawa village
Signal Horn *(fu)*
bamboo
13 x 2 x 2
Collection of the Crosier Asmat Museum
0303

92. TAMMAKA, THE ELDER BROTHER
OF SURUK, New Guinea, Irian Jaya
Asmat people - Bayum village
Dagger *(ndam pisuwe)*
human bone, string netting, seeds, cassowary
feathers
Bone: 12 ½ long
Head: 2 ¼ diameter
Shaft: 1 long
Feathers: 12 long
Collection of the Crosier Asmat Museum
0199

93. Artist Unknown, New Guinea, Irian Jaya
Asmat people
Shell Nose Ornament
shell, string, beeswax
5 ¼ x 3 x ½
Collection of the Crosier Asmat Museum
0683

94. Artist Unknown, New Guinea, Irian Jaya,
Asmat people
Spear *(otsjen)*
palm wood, cassowary claw tip, beeswax,
feathers
111 ¾ x 5 x 1
Collection of the Crosier Asmat Museum
0645

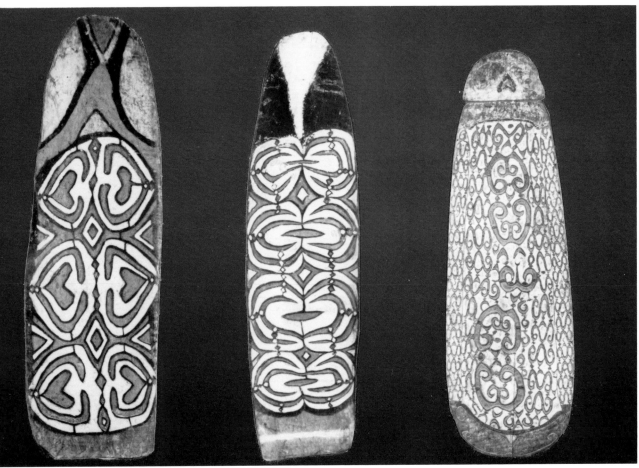

118. SAMU, War Shield *(jamasj)* /
Asmat people - Vakam village

120. SABUGU, War Shield *(jamasj)* /
Asmat people - Ziabok village

124. War Shield *(jamasj)* / Asmat people -
Momogo or Pupis village

95. Artist Unknown, New Guinea, Irian Jaya,
Asmat people
Woman's Paddle *(po)*
wood
66 x 4 ¾ x 3
Collection of the Crosier Asmat Museum
0305

96. DASAN BISUR, New Guinea, Irian Jaya
Asmat people - Atsj village
Man's Paddle *(po)*
wood
165 x 6 ¼ x 1
Collection of the Crosier Asmat Museum
0697

97. Artist Unknown, New Guinea, Irian Jaya
Asmat people - South Casuarina Coast
Ancestor Figures *(kawe)*
wood
37 ¼ x 4 ¾ x 5
Collection of the Crosier Asmat Museum
0313

98. Artist Unknown, New Guinea, Irian Jaya
Asmat people
Bow
wood, rattan
79 x 3 ½ x 2 ¾
Collection of the Crosier Asmat Museum
0662

99. Artist Unknown, New Guinea, Irian Jaya
Asmat people
Ancestor Figure *(kawe)*
ironwood
25 x 5 ¼ x 2 ¾
Collection of the Crosier Asmat Museum
0011

100. Artist Unknown, New Guinea, Irian
Jaya
Asmat people
Ancestor Skull *(ndambirkus)*
human bone, coix seeds, red abrus seeds,
beeswax, string, white cockatoo feathers,
rattan
9 ½ x 5 x 6
Collection of the Crosier Asmat Museum
0567

101. Artist Unknown, New Guinea, Irian Jaya
Asmat people - Buepis village
Ancestor Pole *(mbis)*
painted wood, sago frond tassels
190 x 11 ½ x 12
Collection of the Crosier Asmat Museum
0696

102. AMANDOS AMONOS, New Guinea, Irian Jaya
Asmat people - Jamasj village
Soul Ship *(wuramon)*
painted wood, cassowary feathers, coix seeds, quills
243 x 13 ¾ x 12 ½
Collection of the Crosier Asmat Museum
0697

103. Artist Unknown, New Guinea, Irian Jaya
Asmat people - Sawa or Erma village
Panel
painted ironwood
19 ½ x 11 x ½
Collection of the Crosier Asmat Museum
0210

104. Artist Unknown, New Guinea, Irian Jaya
Asmat people - Casuarina Coast
Man's Bag *(ese)*
sago frond, coix seeds, cockatoo feathers
12 x 10 x ¼
Collection of the Crosier Asmat Museum
0552

105. Artist Unknown, New Guinea, Irian Jaya
Asmat people - Casuarina Coast
Feast Vest *(tisan)*
coix seeds, string
16 x 2 ¼ x ¼
Collection of the Crosier Asmat Museum
0349

106. Artist Unknown, New Guinea, Irian Jaya
Asmat people - Warse village
Spirit Mask *(jipae)*
painted string, coix seeds, cassowary feathers, sago frond
42 x 17 x ⅛
Collection of the Crosier Asmat Museum
0104

107. Artist Unknown, New Guinea, Irian Jaya
Asmat people - Fayit River
Spirit Mask *(jipae)*
string, wood, sago frond
60 x 33 ⅛
Collection of the Crosier Asmat Museum
0433

108. BEWOR, New Guinea, Irian Jaya
Asmat people - Fos village
Sago Pounder *(amosus)*
wood
31 x 19 x 2 ½
Collection of the Crosier Asmat Museum
0630

109. Artist Unknown, New Guinea, Irian Jaya
Asmat people - Casuarina Coast
Canoe Prow *(tsji tsjemen)*
painted wood
33 x 6 x 6
Collection of the Crosier Asmat Museum
0041

110. SOTER PATARKOMON, New Guinea, Irian Jaya
Asmat people - Atsj village
Ajour Carving, 1977
wood
22 x 10 x ½
Collection of the Crosier Asmat Museum
0355

111. Artist Unknown, New Guinea, Irian Jaya
Asmat people - Atsj village
Ajour Carving
wood
6 ½ x 6 ¾ x ½
Collection of the Crosier Asmat Museum
0640

112. Artist Unknown, New Guinea, Irian Jaya
Asmat people - Sawa village
Pseudo-prowhead
painted wood, cassowary feathers
61 x 26 ¼ x 2
Collection of the Crosier Asmat Museum
0659

113. KERAB?, New Guinea, Irian Jaya
Asmat people - Santambor village
Crocodile Pole *(eu)*, 1978
painted wood, job's tears seeds, feathers, sago frond
122 x 9 ½ x 9 ½
Collection of the Crosier Asmat Museum
0684

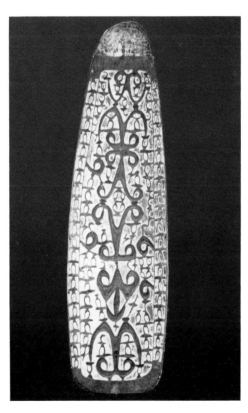

121. **FOMAME, War Shield** *(jamasj)* /
Asmat people - Djakapis village

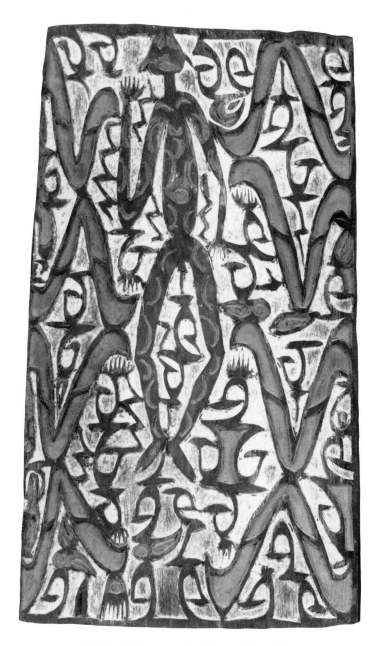

103. **Panel** / Asmat people - Sawa or Erma village

114. Artist Unknown, New Guinea, Irian Jaya
Asmat people - Buepis or Baous village
Ancestor Pole *(mbis),* 1978
ironwood with paint traces, sago frond
117 ¾ x 9 ¼ x 9
Collection of the Crosier Asmat Museum
0685

115. ID, New Guinea, Irian Jaya
Asmat people - Burbis village
Water Container *(mbi suwin)*
bamboo
14 ¼ high, 3 ¼ diameter
Collection of the Crosier Asmat Museum
0557

116. Artist Unknown, New Guinea, Irian Jaya
Asmat people - Casuarina Coast
Paint Bowl *(jifai)*
wood
2 ¾ x 27 ¾ x 3
Collection of the Crosier Asmat Museum
0193

117. APASA, New Guinea, Irian Jaya
Asmat people - Tiau village
War Shield *(jamasj)*
painted wood
79 ½ x 18 ½ x ½
Collection of the Crosier Asmat Museum
0668

118. SAMU, New Guinea, Irian Jaya
Asmat people - Vakam village
War Shield *(jamasj)*
painted wood
78 x 25 x ½
Collection of the Crosier Asmat Museum
0537

119. TITUS TINE, New Guinea, Irian Jaya
Asmat people - Epem village
War Shield *(jamasj)*
painted wood
84 ½ x 21 x ½
Collection of the Crosier Asmat Museum
0661

120. SABUGU, New Guinea, Irian Jaya
Asmat people - Ziabok village
War Shield *(jamasj)*
painted wood
75 ½ x 21 x ½
Collection of the Crosier Asmat Museum
0691

121. FOMAME, New Guinea, Irian Jaya
Asmat people - Djakapis village
War Shield *(jamasj)*
painted wood
79 x 22 ¾ x ½
Collection of the Crosier Asmat Museum
0257

122. Artist Unknown, New Guinea, Irian Jaya
Asmat people - Casuarina Coast
War Shield *(jamasj)*
painted wood
71 x 13 ¼ x ½
Collection of the Crosier Asmat Museum
0389

123. Artist Unknown, New Guinea, Irian Jaya
Asmat people - Pirimapun village
War Shield *(jamasj)*
painted wood
73 x 18 ½ x ½
Collection of the Crosier Asmat Museum
0110

124. Artist Unknown, New Guinea, Irian Jaya
Asmat people - Momogo or Pupis village
War Shield *(jamasj)*
painted wood
71 x 23 ¼ x ½
Collection of the Crosier Asmat Museum
0017

125. PRASIM, New Guinea, Irian Jaya
Asmat people - Batusun village
War Shield *(jamasj)*
painted wood
72 ½ x 23 x ½
Collection of the Crosier Asmat Museum
0667

126. Artist Unknown, Southwest Coast,
Irian Jaya
Asmat People - Pirimapun vicinity
Canoe Prow *(Tsji tsjemen)*
wood, paint
11 x 39 ½ x 5
Collected by Klaus Koch, dated 1965
Collection of the Lowie Museum of
Anthropology, University of California,
Berkeley
38454

127. Artist Unknown, New Guinea, Irian Jaya
Asmat people
Bowl *(jifai)*
wood
6 ⅝ x 23 ¼ x 2 ¾
Gift of Neil and J. Uve Hamilton
83.1.1

128. Artist Unknown, New Guinea, Irian Jaya
Asmat people
Drum *(em)*
wood, paint, lizard skin, seeds, fiber
31 x 8 ¾ x 8
Gift of Howard and Eunice Gelb
79.15.244

129. Artist Unknown, New Guinea, Irian Jaya
Asmat people
Nose Piece
carved and pierced bone
5 ¼ x 1 ¼ x ⅞
Gift of the Crosier Fathers
71.46.03

130. Artist Unknown, New Guinea, Irian Jaya
Asmat people
Horn *(fu)*
bamboo with paint traces
18 ½ high, 3 ¼ diameter
Gift of the Crosier Fathers
71.46.01

131. HERBERT LIBERTSON, American,
contemporary
Manalo: Tayan Warrior, 1980 First contacted
in 1979 on the Brazza River expedition, Irian
Jaya, New Guinea.
bronze, edition of 14 (artist's proof)
17 ½ x 7 x 8 ½
Intended Gift of Herbert Libertson

132. HERBERT LIBERTSON, American,
contemporary
Manalo: Tayan Warrior, 1980
color photograph
12 x 8
Intended gift of Herbert Libertson

Selected Bibliography

Bateson, Gregory. *Naven*. Stanford: University Press, 1958.

Brazeau, Linda. *Melanesian Art: Dialogue with The Spirits*. Milwaukee: Milwaukee Art Museum, 1958.

Buhler, Alfred. *Art of Oceania: A Descriptive Catalogue*. Zurich: Museum Rietberg, 1969.

Buhler, Alfred, Terry Barrow and Charles P. Mountford. *Oceania and Australia: The Art of the South Seas*. Art of the World Series. London: Methuen, 1962.

Cranstone, B.A.L. *Melanesia: A Short Ethnography*. London: The British Museum, 1961.

Creighton University Art Gallery. *The Asmat: Redefining Culture*. Omaha, Nebraska: 1984.

D'Arcy Galleries. *The Caves of the Karawari*. New York: 1968.

Forge, Anthony. "Style and Meaning in Sepik Art." In *Primitive Art and Society*. Edited by Anthony Forge. London: Oxford University Press, 1973: 169-192.

Forge, Anthony. "Three Kamanggabi Figures from the Arambak People of the Sepik District." New York: The Museum of Primitive Art. *Three Regions of Melanesian Art*, 1960: 6-10.

Gerbrands, Adrian A. *The Asmat of New Guinea: The Journal of Michael Clark Rockefeller*. New York: The Museum of Primitive Art, c. 1967.

Guiart, Jean. *The Arts of the South Pacific*. Translated by A. Christie. New York: Golden Press, 1963.

Greub, Suzanne, ed. *Authority and Ornament: Art of the Sepik River, Papua, New Guinea*. Texts by Suzanne Greub, Christian Kaufmann, Meinhard Schuster, Brigitte Hauser- Schaublin and Christin Kocher-Schmid. Basel: Tribal Art Center, 1985.

Konrad, Gunter, Ursula Konrad and Tobias Schneebaum. *Asmat: Leben mit den Ahnen. (Life with the Ancestors)*. Glashutten, West Germany: Friedhelm Bruckner, 1981.

Linton, Ralph and Paul Wingert. *Arts of the South Seas*. New York: The Museum of Modern Art, 1946.

The Metropolitan Museum of Art. *Art of Oceania, Africa and the Americas from the Museum of Primitive Art*. New York: 1969.

Minnesota Museum of Art. *Melanesian Images*. Essay by John Edler. St. Paul: 1981.

The Museum of Primitive Art. *The Art of the Asmat, New Guinea*. Collected by Michael C. Rockefeller. New York: 1962.

The Museum of Primitive Art. *Three Regions of Melanesian Art*. Essays by Anthony Forge and Raymond Clausen. New York: University Publishers, 1960.

Newton, Douglas. *Crocodile and Cassowary: Religious Art of the Upper Sepik River, New Guinea*. New York: The Museum of Primitive Art, 1971.

Newton, Douglas. *New Guinea Art in the Collection of the Museum of Primitive Art*. Greenwich, Connecticut: New York Graphic Society, 1967.

Parsons, Lee. *Ritual Arts of the South Seas: The Morton D. May Collection*. St. Louis: The St. Louis Art Museum, 1975.

Poignant, Roslyn. *Oceanic Mythology.* London: Paul Hamlyn, 1967.

Schmitz, Carl A. *Oceanic Art: Man, Myth and Image in the South Seas.* New York: Harry N. Abrams, Inc., 1969.

Schmitz, Carl A. *Oceanic Sculpture: Sculpture of Melanesia.* London: Melbourne Press, 1962.

Schneebaum, Tobias. *Asmat Images from the Collection of the Asmat Museum of Culture and Progress.* Agats: The Asmat Museum of Culture and Progress, 1985.

Schneebaum, Tobias. "Some Thoughts on Tools and Changing Carvings in Asmat." *Pacific Arts Newsletter* 16 (January 1983): 7-14.

University of California, Los Angeles. Ethnic Art Galleries. *Art of New Guinea: Sepik, Maprik and Highlands.* California: 1967.

Wardwell, Allen. *The Art of the Sepik River.* Chicago: The Art Institute of Chicago, 1971.

Wingert, Paul. *Primitive Art: Its Traditions and Styles.* New York: Oxford University Press, 1962.

Zegwaard, Gerard A. "Headhunting Practices of the Asmat of Netherlands New Guinea." *American Anthropologist,* vol. 61, no. 6 (1959): 1020-1041.

Minnesota Museum of Art Staff

DIRECTOR'S OFFICE

M. J. Czarniecki III, *Director*
Ricka Robb Kohnstamm, *Assistant to the Director*
Roberta Andrich, *Director's Office Assistant*

Partnership
Steven G. Novak, *Assistant to the Directors*

Development & Membership
Janet P. Bisbee, *Assistant Director for Development & Membership*
(vacant), *Development Specialist*
Ann Toscano, *Development Assistant*

PROGRAMS

James J. Kamm, *Associate Director for Program & Planning*
Holly Wolhart, *Programs Supervisor*

Collections
Gloria C. Kittleson, *Curator of Collections*
Leanne A. Klein, *Associate Curator for Collections Management*
Ann Godfrey, *Curatorial Assistant*

Exhibitions
Katherine Van Tassell, *Curator of Exhibitions*
Lisa Sampson, *Assistant Curator of Exhibitions*
David Madzo, *Curatorial Assistant*
Steven L. Stoa, *Assistant to the Curator*

The MUSEUM SCHOOL
Ann Godfrey, *Education Specialist*
Elaine Johnson, *Education Specialist*
Marilyn Macy, *Assistant*

Marketing
Tim Jennen, *Media Relations Supervisor*
Amy Kirkpatrick, *Graphics Technician*

ADMINISTRATION & FINANCE

Paul Orman, *Associate Director for Finance & Administration*

Finance & Personnel
Karen Kapphahn, *Accounting Specialist*
Laura Manske, *Administrative Technician*
Allan Willig, *Finance Assistant*
Ramona Weselmann, *Personnel Supervisor*

Plant & Security
Tom Stanger, *Physical Plant and Security Supervisor*
David Koepke, *Safety and Security Technician*
Kelly Bucheger, *Front Desk Officer/ Receptionist*
George Abrass, *Custodian*

Security Officers
Julia Fearing
Greg Mueller
Hung Dai Nguyen
Kelvin Nichols
Tim Peterson
Alexander Podulke
Daniel Rahey
Rachel Zemmer

Photography Credits

Eastern Photo Studios, New York
67

Nick Felice, Minneapolis
4, 12, 15, 19, 22, 23, 24, 28, 33, 34, 37,
39, 59, 61, 63, 64, 65, 66, 77, 78, 128,
129, 130

Negative #A93406
Field Museum of Natural History, Chicago
81

Jerry Mathiason, Minneapolis
6,7, 14, 16, 53, 55, 58, 69, 70

Gary Mortensen
18, 74

Gene Plaisted, O.S.C.
82, 84, 97, 107, 110, 112, 123

Patrick Renschen, Hastings, Nebraska
89, 91, 100, 101, 102, 103, 116, 118,
120, 121, 124

Catalog #377599
Department of Anthropology
The National Museum of Natural History
Smithsonian Institution
68

Negative #65472
The University Museum, University of
Pennsylvania, Philadelphia
40

Colophon

This catalog was printed in an edition of
750 by Ramaley Printing and was bound by
Musclebound Bindery. The color separations
were made by Sly Litho. The type was set in
Sabon and Melior Bold by Northwestern
Printcrafters. The catalog was designed by
Amy Kirkpatrick.

66. Hunting Charm *(yipwon)*. Modern version of an earlier style. / Middle Sepik, Karawari River, Arambak people